A Bouquet of Quilts

Garden-Inspired Projects for the Home

C&T PUBLISHING

Edited by Jennifer Rounds & Cyndy Lyle Rymer

© 2002 C & T Publishing

Development Editors: Jennifer Rounds, Cyndy Lyle Rymer

Technical Editors: Catherine Comyns, Joyce Lytle, and Ann Gosch

Copyeditor: Joan Cravens

Cover Designer: Kristen Yenche

Design Director/Book Designer: Kristen Yenche

Illustrator: Richard Sheppard

Production Assistant: Kirstie L. McCormick

Published by C&T Publishing, Inc. P.O. Box 1456, Lafayette, California 94549

Cover Image: *Lily of the Valley Trapunto Pillow* (page 52), designed by Hiroko Shimbo, photo by Norio Ando

Back Cover Images: *Dutch Treat Tulip Basket* (page 7) by Akiko Nishikawa, photo by Masakai Yamamoto; *Buds in a Basket* (page 29) by Sachiko Yasuda, photo by Masakai Yamamoto

Stock Photography used throughout the book courtesy of Photospin.com

Attention Teachers: C&T Publishing, Inc. encourages you to use this book as a text for teaching. Contact us at 800-284-1114 or www.ctpub.com for more information about the C&T Teachers Program.

Library of Congress Cataloging-in-Publication Data

Rounds, Jennifer,

 A bouquet of quilts : garden-inspired projects for the home / edited by Jennifer Rounds & Cyndy Lyle Rymer.

 p. cm.

Includes index.

 ISBN 1-57120-134-3 (paper trade)

 1. Patchwork—Patterns. 2. Appliqué—Patterns. 3. Quilts—Japan.
4. Flowers in art. I. Rymer, Cyndy Lyle II. Title.

 TT835 .R675 2002

 746.46'041—dc21

 2001006588

Printed in China

10 9 8 7 6 5 4 3 2

Dedicated to Joyce Lytle, our technical guru and friend. Thanks for your incredible patience! And to the Japanese quilters featured in this book: You are awesome.

Many thanks to Hiroko Shibuya for her assistance.

Contents

INTRODUCTION

With *A Bouquet of Quilts,* C&T Publishing presents the creative vision of a remarkable group of Japanese quilters. The projects come from Nihon Vogue's preeminent quilting magazine, *Quilts Japan.* This lovely magazine is not widely available outside Japan, and so we are both honored and delighted to bring the work of these wonderful craftswomen to a larger audience.

As you would expect, *Quilts Japan* features Asian design traditions applied to quiltmaking, but it is the quilters' interpretations of traditional Western quilting forms that surprise and delight us and that we feature here. More than anything else, their wonderful quilts reveal the universal nature of quiltmaking. Whatever the nation, culture, or dialect, Log Cabin blocks, Irish Chains, Flower Baskets, and pretty floral appliqués are truly the universal language of quilting. What's more, we realize that quiltmakers worldwide find endless inspiration in the same place—the natural world. Clearly, we share a profound and abiding love for our garden muse and celebrate her beautiful bounty with our quilts.

While we have so much in common with our fellow quilters from Japan, we need to acknowledge a few qualities that distinguish our quilting neighbors. Japanese quiltmakers take pride in making a few special quilts a year and lavish tremendous attention to every detail from design to completion. Often they dedicate more than a year to one extraordinary quilt. This deliberate approach to the quiltmaking process results in spectacular quilts that are polished, artful, and unique. Each quilt in the collection exemplifies this pursuit of excellence and, further, teaches us much about design, color use, and craftsmanship.

Additionally, Japanese quilt designers find creative ways to apply quiltmaking to home décor and personal items. A mind-boggling display of their inventiveness is part of every issue of *Quilts Japan. A Bouquet of Quilts* includes a variety of these fun mini projects. Except for the sewing notions kit, all the little projects derive from the larger bed quilts, throws, and wallhangings included in this book.

The pattern instructions for each project were originally drafted in metric units. Technical editor Catherine Comyns recalculated those measurements into the American standard, but kept the metric for quilters who prefer to follow the original directions. We've put that information in chart form for easy use.

Be aware that we had to make a few mathematical adjustments to accommodate inches and yards so the final quilts or mini projects in the American standard measurements may be slightly different in size from the metric. Also, be sure to choose the project templates that correspond to the measurement unit you are using because there are both metric and American standard templates for some patterns. Catherine, also found ways to simplify the piecing of some blocks and borders.

Here's a preview of the quilted treasures you'll find in *A Bouquet of Quilts:*

Dutch Treat Tulip Basket Quilt and Pillows: A jazzy, animated quilt that is perfect for scrap quilt fans and for those who love springtime's brightest and loveliest blooms. Looking for a quick project? Make one or both of the accent pillows.

Watering Can Bouquet Sampler Quilt: This floral sampler has a central medallion featuring a watering can filled with a bouquet of whimsical blooms and borders decorated with appliquéd vines and flowers. The folk-art style of the watering can and flowers creates a cheerful garden-themed quilt.

Buds in a Basket Quilt: A scrappy appliqué quilt made with reproduction and Provençal fabrics. Put your personal stamp on this quilt by using your favorite collection of fabrics. For an easy decorative project make and frame just one block for a sweet picture that will liven up any room.

Sewing Notions Kit: One of the wonderful aspects of *Quilts Japan* is the clever way the designers apply quilting to everyday objects. This portable kit offers a great way to organize your tools and notions for projects on the go.

Rainbow Garden Log Cabin Quilts: This is a fabulous quilt with paper-pieced blocks and a beautiful floral appliqué border. Miniature enthusiasts can tackle the $2\frac{1}{4}$" block instructions to create the quilt featured in the picture. For an easier approach, we offer a 4" block for those who love the pattern and might be daunted by the smaller scale. We also include a delightful pillow project.

Spring Irish Chain Quilt: The colors of fresh spring grass add sparkle to this traditional Irish Chain with a twist: alternate plain blocks are decorated with lily-of-the-valley trapunto. A double swag border tied with bows completes the quilt. Create a charming bedroom ensemble with the two coordinating pillow projects.

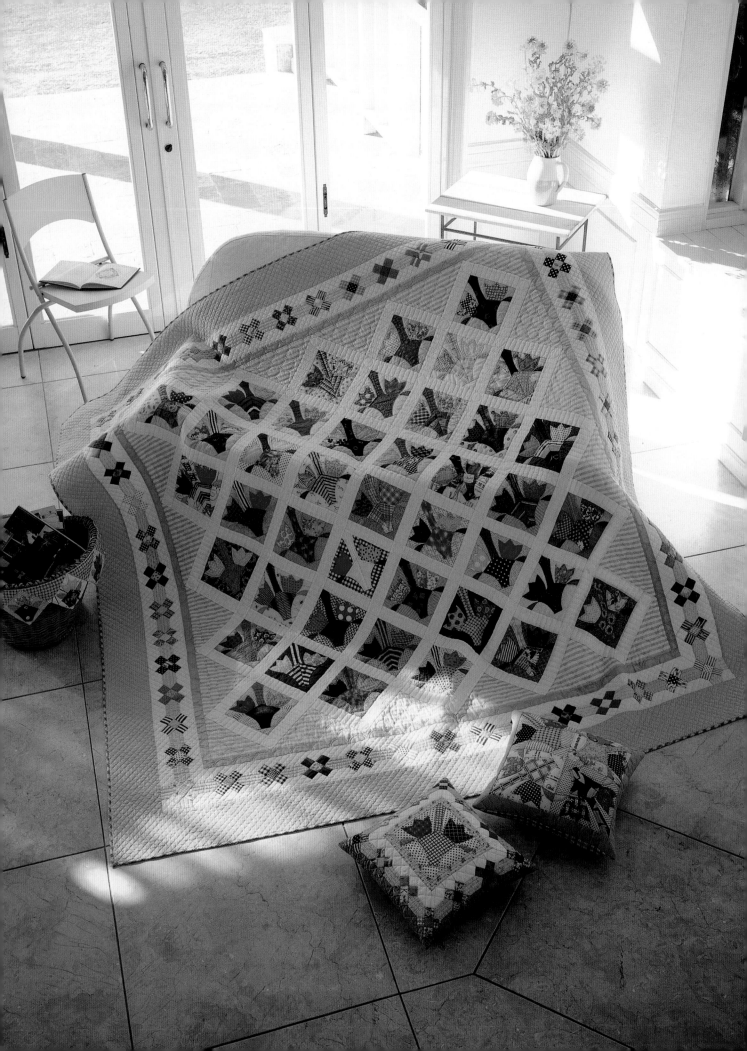

Dutch Treat Tulip Basket Quilt

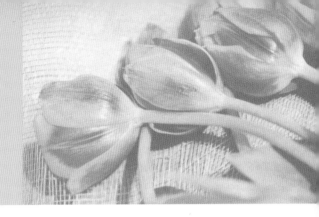

Finished Size: 80" x 80" (203.4 cm x 203.4 cm)
Techniques: Piecing/Appliqué

Made by Akiko Nishikawa
Photo by Masaki Yamamoto

Here's a chance to assemble your cheeriest fabrics into a lively bouquet of fresh tulips. The blue, white, and yellow in the borders compliment the bright display of blossoms. If you love the quilt, but want to try a smaller project, take a look at the pillows on pages 13 and 16.

FABRIC REQUIREMENTS

U.S.		Metric
2 yards total (you can cut pieces for two blocks from 1/8 yard)	Assorted prints and solids for the background of each block	1.8 meters total (you can cut pieces for two blocks from 10 cm)
2 1/2 yards total	Assorted lights and brights for the basket handles, baskets, tulips, and pieced middle border	2.3 meters total
1/3 yard total	Assorted greens for the leaves	20 cm total
2 3/4 yards OR 2 3/8 yards if you are cutting lengthwise strips	White for the sashing and pieced middle border	2.4 meters OR 2.2 meters if you are cutting lengthwise strips
1 yard	Green-and-white strips for the setting triangles	85 cm
1/4 yard	Light green for the inner border	27 cm
2 1/4 yards OR 2 1/2 yards if you are cutting lengthwise strips	Yellow for the pieced middle and outer border	2 meters OR 2.2 meters if you are cutting lengthwise strips
5/8 yard	Blue and white plaid for binding	57 cm
5 1/2 yards	Backing	5 meters
84" x 84" square	Batting	214 cm x 214 cm square
	Clear template plastic	

NOTE: The directions for piecing the border on this quilt have been simplified. The visual effect is similar to the original border but the modified piecing makes construction easier to tackle.

CUTTING

U.S.	Assorted Backgrounds	Metric
	Tulip background (A): Cut 41 and 41r.	
	Basket background (E): Cut 41 and 41r.	
2½" x 2½" square	Block corner (G): Cut 21, then cut each square in half diagonally to make two triangles. (You will have one extra triangle.)	7 cm x 7 cm square

NOTE: The tulip background (A), basket background (E), and the corner squares could all be cut from the same fabric for each block.

U.S.	Assorted Lights and Brights	Metric
	Basket handles (D): Cut 41. Mark dot.	
	Tulips (C): Cut 41 and 41r. Mark dot.	
	Baskets (F): Cut 41. Mark dot.	
Cut 260 total 1⅝" x 1⅝" squares.	Pieced middle border Nine-Patch blocks: Cut 52 sets of four matching squares, the rest are scrappy	Cut 260 total 4 cm x 4 cm squares.

U.S.	Assorted Greens	Metric
	Leaves (B): Cut 41 and 41r.	

U.S.	White	Metric
2⅛" x 6⅞"	Sashing: Cut 50.	5.2 cm x 17.2 cm
2⅛" x 10⅛"	Sashing: Cut 2 for Rows 1 and 9.	5.2 cm x 25.2 cm
2⅛" x 26⅛"	Sashing: Cut 2 for Rows 2 and 8.	5.2 cm x 65.2 cm
2⅛" x 42⅛"	Sashing: Cut 2 for Rows 3 and 7.	5.2 cm x 105.2 cm
2⅛" x 58⅛"	Sashing: Cut 2 for Rows 4 and 6.	5.2 cm x 145.2 cm
2⅛" x 74⅛"	Sashing: Cut 2 for Row 5.	5.2 cm x 185.2 cm
1⅝" x 1⅝" squares	Pieced middle border Nine-Patch blocks: Cut 96.	4 cm x 4 cm squares
⬠	Pieced middle border. Cut 8 J corner pieces.	⬠
◁	Pieced middle border. Cut 4K and 4Kr.	◁

U.S.	Green-and-white stripe	Metric
12⅝" x 12⅝" squares	Setting triangles: Cut 4, then cut each square diagonally into quarters (these triangles are slightly oversized).	31.5 cm x 31.5 cm squares
7¾" x 7¾" squares	Setting triangle corners: Cut 2, then cut each square in half diagonally (these triangles are slightly oversized).	19.3 cm x 19.3 cm squares

U.S.	Light green	Metric
1⅛" x 59¼"	Side inner borders: Cut 2.	3.7 cm x 148.4 cm
1⅛" x 60½"	Top and bottom inner borders: Cut 2.	3.7 cm x 153.4 cm

U.S.	Yellow	Metric
5½" x 75"	Side outer borders: Cut 2.	14.2 cm x 190 cm
5½" x 85"	Top and bottom outer borders: Cut 2.	14.2 cm x 215 cm
1⅝" x 1⅝" squares	Pieced middle border Nine-Patch blocks: Cut 112.	4 cm x 4 cm squares
2" x 2" squares	Pieced border: Cut 16, then cut each square in half diagonally.	5 cm x 5 cm squares

BLOCK ASSEMBLY

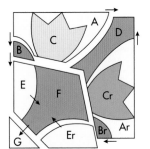

Arrows indicate pressing direction.

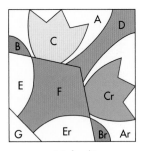

Make 41

1. Sew one leaf (B/Br) to each tulip background (A/Ar). Press each seam toward the leaf.

2. Appliqué one tulip (C/Cr) to each tulip background (A/Ar) using the appliqué method of your choice.

3. Sew the pieces made in Steps 1 and 2 to each side of the basket handle (D), clipping curves as needed. Press seams toward basket handle.

4. Sew one basket background (E/Er) to each side of the basket (F), clipping the curves as needed. Press seams toward basket.

5. Sew block corner (G) to the basket bottom. Press seams toward corner.

6. Sew the basket unit to the tulip unit. (This is an inset seam.) With the basket unit on top, sew from the outer edge to the dot. Leave the needle in the fabric, and lift the presser foot. Clip only the handle's seam allowance, cutting almost to the dot. Pivot both the basket and tulip units while the needle is still in the fabric. Match the remainder of the seam, lower the presser foot, and sew to the other outer edge. Press the seam toward the tulip unit. Make 41 blocks.

QUILT ASSEMBLY

1. Arrange the blocks on point into five rows of five blocks each, alternating with four rows of four blocks each.

2. Place the short 2⅛" x 6⅞" (5.2 cm x 17.2 cm) sashing strips between blocks and at the end of each diagonal row, as shown in the assembly diagram. Sew short sashing strips and blocks into diagonal rows. Press seams toward the sashing strips.

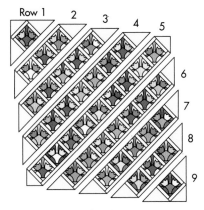

Assembly diagram

3. Sew long sashing strips to the block rows as shown. Press seams toward the sashing strips.

4. Sew a side-setting triangle (cut from a 12⅝" (31.5 cm) quarter-square triangle) to each end of every row except row 5. Remember, this triangle is cut slightly oversized. Press seams toward the side-setting triangles.

5. Center and sew a corner triangle (cut from the 7¾" (19.3 cm) half-square triangle) to rows 1 and 9 and each end of row 5. Remember, this triangle is cut slightly oversized. Press seams toward the corner triangles.

6. Sew rows together. Press seams toward the sashing strips.

7. Trim the quilt to measure 59 1/4" x 59 1/4" (148.4 cm x 148.4 cm), making sure there is a 1/4" (6 mm) seam allowance all around.

INNER BORDER

1. Sew one 1 1/8" x 59 1/4" (3.7 cm x 148.4 cm) inner border to each side of the quilt top. Press seams toward the inner border.

2. Sew one 1 1/8" x 60 1/2" (3.7 cm x 153.4 cm) inner border to the top and bottom. Press seams toward the inner border.

PIECED MIDDLE BORDER

1. Make Nine-Patch blocks using the 1 5/8" x 1 5/8" (4 cm x 4 cm) squares and the color placement shown. Press toward Color B squares.

	Color B	
Color B	Color A	Color B
	Color B	

Make 48.

	Color B	
Color B	Color A	Color B
	Color B	

Make 4.

2. Make H, I/Ir, J, and K/Kr from template plastic. Transfer the dotted lines onto the H and I templates.

Note: Before proceeding to Steps 3 and 4, be sure that you have already cut the final yellow borders and other pieces indicated in the cutting instructions.

3. Cut the remaining white fabric into 2 1/4" (5.5 cm) wide strips.

4. Cut the remaining yellow fabric into 1 3/4" (4.2 cm) wide strips.

5. Sew a yellow strip between two white strips. Press seams toward the yellow fabric. Make eight strip sets.

6. Cut 96 H triangles, being careful to line up the dotted line on the seam line between the yellow and the white fabrics.

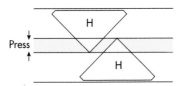

7. Sew one H triangle to the opposite sides of 40 of the Nine-Patch blocks made in Step 1. Press.

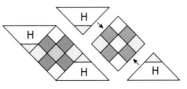

Make 40.

8. Sew together the units made in Step 7 to make two side border strips of 10 units and two top and bottom strips of 10 units. Press.

9. Sew one 2" (5 cm) half-square triangle to each K shape and each Kr shape. Press seams toward the yellow half-square triangles. Trim each slightly oversized yellow triangle even with the edges of K and Kr.

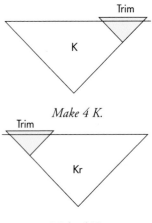

Make 4 K.

Make 4 Kr.

10. Sew two K units made in Step 9 to one Nine-Patch block. Sew an H triangle to a third side of the Nine-Patch block. Press. Make four. Sew these units to each end of the side border strips made in Step 8. Press.

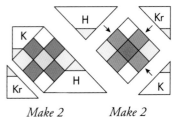

Make 2 *Make 2*

Side border end units

11. Sew the side border strips to the sides of the quilt top. Press.

12. Sew one of the H triangles to one end of each of the four remaining Nine-Patch blocks made in Step 1. Press. Make four.

13. Trim four H triangles to fit the I template and four more H triangles to fit Ir.

14. Sew a 2" (5 cm) yellow half-square triangle to each I/Ir shape. Press. Trim yellow fabric even with straight edges of the white fabric

Make 4

Make 4r

15. Sew the I units to the other side of the Nine-Patch/H units. Press. Sew the units to each end of the top and bottom borders. Press.

Make 2 *Make 2*

Top and bottom border units next to corner

16. Sew two 2" (5 cm) yellow half-square triangles to each J shape. Press seams toward the yellow triangles. Trim yellow fabric even with straight edges of the white fabric. Make eight.

Make 8

17. Sew two of the J units made in Step 16 to the Nine-Patch blocks. Press. Make four.

18. Sew one Ir unit to each J/Nine-Patch/J unit. Press. Make four.

Top and bottom border corners; make 4.

19. Sew units made in Step 18 to each end of the top and bottom borders. Press.

20. Sew top and bottom borders to the quilt top. Press.

FINAL BORDER

1. Measure the quilt top lengthwise through the center, and trim the two side borders to this length. Sew the two side borders to the quilt top. Press seams toward borders.

2. Measure the quilt width through the center, including side borders, and trim top and bottom borders to this length. Sew top and bottom borders to the quilt top. Press seams toward the borders.

FINISHING

Layer and baste the backing, batting, and quilt top.

The quiltmaker quilted $1/4$" (6 mm) away from the edges of each piece in the tulip blocks. Straight lines, $5/8$" (16 mm) apart, were quilted across the width of the sashing strips. Where the sashing strips meet, a 1 $1/8$" (3 cm) diameter circle was quilted. A double clamshell design is quilted in the setting triangles; it extends into the inner light green border. Straight lines, $1/4$" (6 mm) apart and parallel to the body of the quilt top, are quilted in the yellow areas of the pieced border. A $1/2$" (12 mm) diagonal grid was quilted in the rest of the pieced middle border extending into the outer border.

Dutch Treat Tulip Basket Pillows

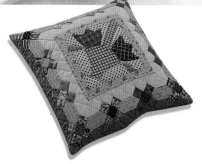

ONE BLOCK DUTCH TREAT TULIP BASKET PILLOW

Finished Size: 18⅞" x 18⅞" (47.8 cm x 47.8 cm)

This terrific adaptation makes use of a single block set within a small section of the quilt's pieced border for an eye-catching decorator touch. Create an accent pillow using a four-block version set within a simple border (see page 16).

U.S.	Fabric Requirements	Metric
½ yard total	Assorted light and bright prints for the tulip block and Nine-Patch blocks	46 cm total
⅓ yard	Blue for pieced border	25 cm
⅓ yard	Yellow print for border	25 cm
⅓ yard	White for pieced border	25 cm
¾ yard	Muslin for lining	60 cm
⅝ yard	Backing	50 cm
23" x 23" square	Batting	60 cm x 60 cm square
20" x 20" square	Pillow form	50.8 cm x 50.8 cm square

CUTTING

U.S.	Blue	Metric
1⅝" x 1⅝" squares	Nine-Patch blocks: Cut 16.	4 cm x 4 cm squares
3⅜" x 3⅜" squares	Pieced border: Cut 2, then cut each square in half diagonally (this piece is slightly oversized).	8.5 cm x 8.5 cm squares
◇	Pieced border: Cut 4 K and 4 Kr.	◇

U.S.	White	Metric
1⅝" x 1⅝" squares	Nine-Patch blocks: Cut 8.	4 cm x 4 cm squares
◇	Pieced border: Cut 2 K and 2 Kr.	◇

U.S.	Assorted lights and brights	Metric
	Tulip background (A): Cut 1 and 1r.	
	Basket background (E): Cut 1 and 1r.	
	Basket handle (D): Cut 1. Mark dot.	
	Tulip (C) : Cut 1 and 1r.	
	Basket (F): Cut 1. Mark dot.	
	Leaf (B): Cut 1 and 1r.	
2½" x 2½" square	Corner (G): Cut square in half diagonally.	7 cm x 7 cm square
Cut 60 total. 1⅝" x 1⅝" squares.	Pieced border Nine-Patch blocks: Cut 12 sets of 4 matching squares, the rest are scrappy.	Cut 60 total. 4 cm x 4 cm squares.

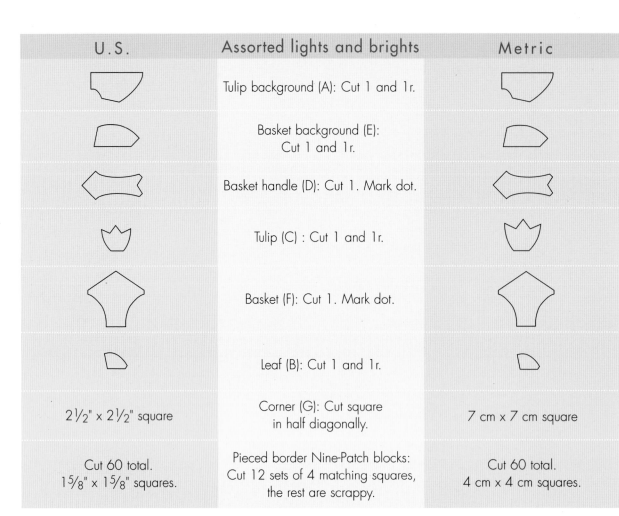

NOTE: The tulip background (A), basket background (E), and corner square can all be cut from the same fabric for each block.

U.S.	Yellow	Metric
2" x 6⅞"	Inner side borders: Cut 2.	5.1 cm x 17.2 cm
2" x 9⅝"	Inner top and bottom borders: Cut 2.	5.1 cm x 25 cm
1⅝" x 1⅝" squares	Nine-Patch blocks: Cut 24 squares.	4 cm x 4 cm squares
2" x 2" squares	Pieced border: Cut 8, then cut each square in half diagonally (these pieces are slightly oversized).	5 cm x 5 cm squares

U.S.		Metric
23" x 23" square	Muslin for lining	58 cm x 58 cm square
19⅜" x 19⅜" square	Backing	49 cm x 49 cm square
23" x 23" square	Batting	58 cm x 58 cm square

BLOCK ASSEMBLY

Follow Block Assembly instructions on page 10, Steps 1–6. Make one block.

INNER BORDER

1. Sew one 2" x 6 7/8" (5.1 cm x 17.2 cm) yellow inner border to both sides of the block. Press seams toward the inner border.

2. Sew a 2" x 9 7/8" (5.1 cm x 25 cm) inner border to the top and bottom of the block. Press seams toward the inner border.

PIECED BORDER

1. Make Nine-Patch units using the 1 5/8" x 1 5/8" (4 cm x 4 cm) squares and color placement shown. Press.

Make 8

Make 4

2. Make H, I/Ir, J, and K/Kr from the template plastic.

Transfer dotted lines onto H and I templates.

Note: Before proceeding to Steps 4, 5, and 6, be sure that you already have cut all other pieces indicated in the cutting instructions.

3. Cut remaining white and blue fabrics into two 2 1/4" (5.5 cm) wide strips each.

4. Cut remaining yellow fabric into two 1 3/4" (4.2 cm) wide strips.

5. Sew a yellow strip between a white strip and a blue strip. Press the seams toward the yellow fabric. Make two strip sets.

6. Cut eight H triangles from the white side of the strips made in Step 5 and eight H triangles from the blue side of the strips.

Be careful to line up the dotted line on the appropriate seam line between yellow and white or blue fabrics.

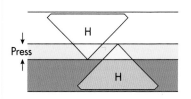

7. From four of the yellow/white H triangles, cut two I and two Ir.

8. Sew a yellow 2" (5 cm) half-square triangle to each I/Ir shape. Press. Trim yellow fabric even with straight edges of the white fabric.

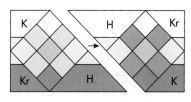

Make 2 *Make 2r*

9. Sew a 2" (5 cm) half-square triangle to two white K's and two white Kr's, four blue K's and four blue Kr's. Press the seam toward the yellow half-square triangle. Trim the yellow triangle even with the edges of K/Kr.

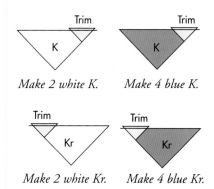

Make 2 white K. *Make 4 blue K.*

Make 2 white Kr. *Make 4 blue Kr.*

SIDE PIECED BORDERS

1. To four of the Nine-Patch blocks, sew an H triangle, a white K/Kr unit, and a blue K/Kr unit as shown to make two side borders.

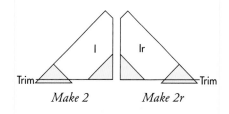

Make 2 side borders.

2. Sew side borders to the pillow top. Press.

TOP AND BOTTOM PIECED BORDERS

1. To a Nine-Patch block, sew a white H triangle and blue H triangle. Press. Make one each for the top and bottom borders.

Make 2 for top and bottom border.

2. To a Nine-Patch block, sew an I triangle unit made in Step 8 and a blue H triangle. Make two. Press.

3. Sew together the units made in Steps 1 and 2. Press. Make two.

4. To a Nine-Patch block, sew a blue K unit, a white Ir unit, and one blue $3^3/_8$" (8.5 cm) triangle as shown above. Press. Make two.

5. To a Nine-Patch block, sew a blue Kr unit, a blue H triangle, and a $3^3/_8$" (8.5 cm) triangle as shown above. Press. Make two.

6. Sew units made in Steps 4 and 5 to each end of the units made in Step 3 to make the top and bottom borders. Press. Make two.

7. Sew the top and bottom borders to the pillow top. Press.

QUILTING

Layer the pillow top with the batting and muslin before basting and quilting.

The quilting design includes stitching $1/_4$" (6 mm) inside the shape of each appliqué piece. Straight lines were added through the yellow inner border as well as through the yellow pieces of the pieced border. The rest of the pieced border was quilted in-the-ditch with diagonal lines that follow the lines of the Nine-Patch blocks.

FINISHING

1. Trim the quilted pillow top to measure $19^3/_8$" x $19^3/_8$" (49 cm x 49 cm).

2. Layer the pillow top to the backing, wrong sides together. Sew, starting 2" (5 cm) from one corner and finishing 2" (5 cm) away from the other corner on the same side.

3. Trim the corners. Turn the pillow right side out and press carefully.

4. Insert the pillow form and hand sew the opening closed.

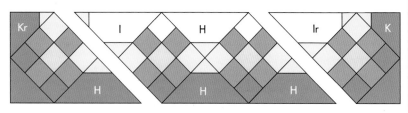

Top and bottom borders: Make 2.

FOUR BLOCK DUTCH TREAT TULIP BASKET PILLOW

Finished Size: 18.5" x 18.5" (47.8 cm x 47.8 cm)

U.S.	Fabric Requirements	Metric
¾ yard total	Assorted print and solid scraps for the tulip blocks	69 cm total
¼ yard	Blue for border	20 cm
¾ yard	Muslin for lining	60 cm
⅝ yard	Backing	50 cm
23" x 23" square	Batting	60 cm x 60 cm square
20" x 20" square	Pillow form	50.8 cm x 50.8 cm square

CUTTING

U.S.	Assorted Backgrounds	Metric
	Tulip background (A): Cut 4 and 4r.	
	Basket background (E): Cut 4 and 4r.	
2½" x 2½" square	For corner (G): Cut 2, then cut each square in half diagonally to make two triangles (you will have one extra triangle).	7 cm x 7 cm square

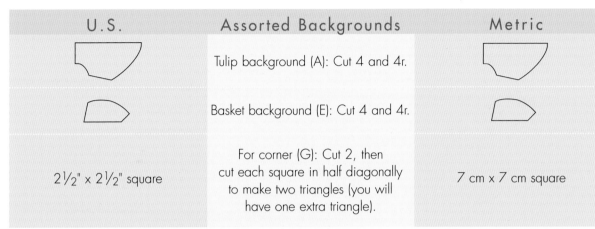

NOTE: The tulip background (A), basket background (E), and corner squares can all be cut from the same fabric for each block.

U.S.	Assorted Prints and Solids	Metric
	Basket handles (D): Cut 4. Mark dot.	
	Tulips (C): Cut 4 and 4r.	
	Baskets (F): Cut 4. Mark dot.	
	Leaves (B): Cut 4 and 4r.	
3½" x 13¼"	Side borders: Cut 2.	9.2 cm x 33.2 cm
3½" x 19¼"	Top and bottom borders: Cut 2.	9.2 cm x 49.2 cm
23" x 23" square	Muslin for lining	60 cm x 60 cm square
19" x 19" square	Backing	49 cm x 49 cm square

BLOCK ASSEMBLY

1. Follow Block Assembly instructions on page 10, Steps 1–6. Make four blocks.

2. Sew the four blocks together, with the bases of the baskets meeting in the center of the pillow top.

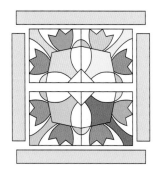

BORDERS

1. Sew side borders to the pillow top. Press seams toward the borders.

2. Add the top and bottom borders. Press seams toward the borders.

QUILTING

Layer the pillow top with the batting and the muslin before basting and quilting.

The pillow was quilted $^1/_4$" (6 mm) inside the shape of each appliqué piece. The borders of the pillow top were quilted in parallel diagonal lines.

FINISHING

1. Trim the quilted pillow top to measure 19" x 19" (49 cm x 49 cm).

2. Layer the pillow top and the backing, wrong sides together. Sew, starting 2" (5 cm) from one corner and finishing 2" (5 cm) away from the other corner on the same side.

3. Trim the corners. Turn the pillow right side out, and press carefully.

4. Insert the pillow form, and hand sew the opening closed.

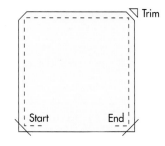

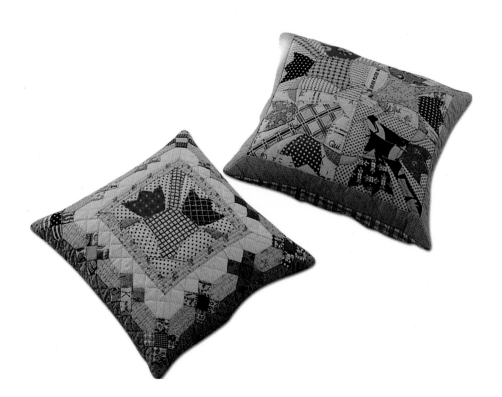

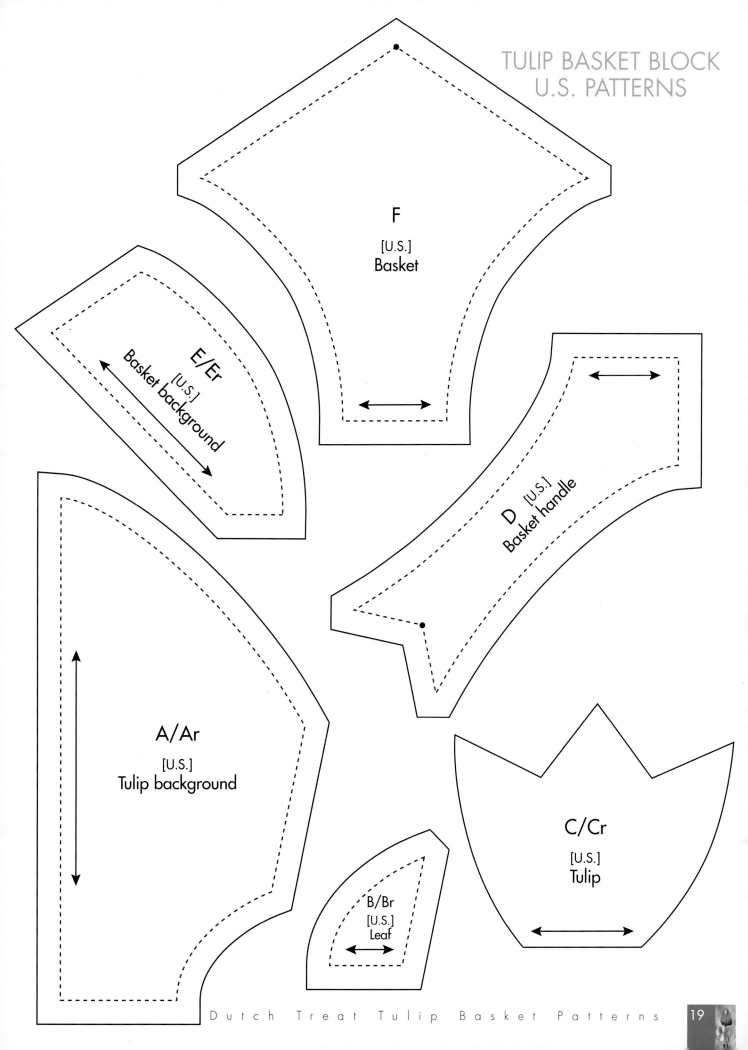

F

[U.S.]
Basket

E/Er

[U.S.]
Basket background

D [U.S.]
Basket handle

A/Ar

[U.S.]
Tulip background

B/Br
[U.S.]
Leaf

C/Cr

[U.S.]
Tulip

TULIP BASKET BLOCK
METRIC PATTERNS

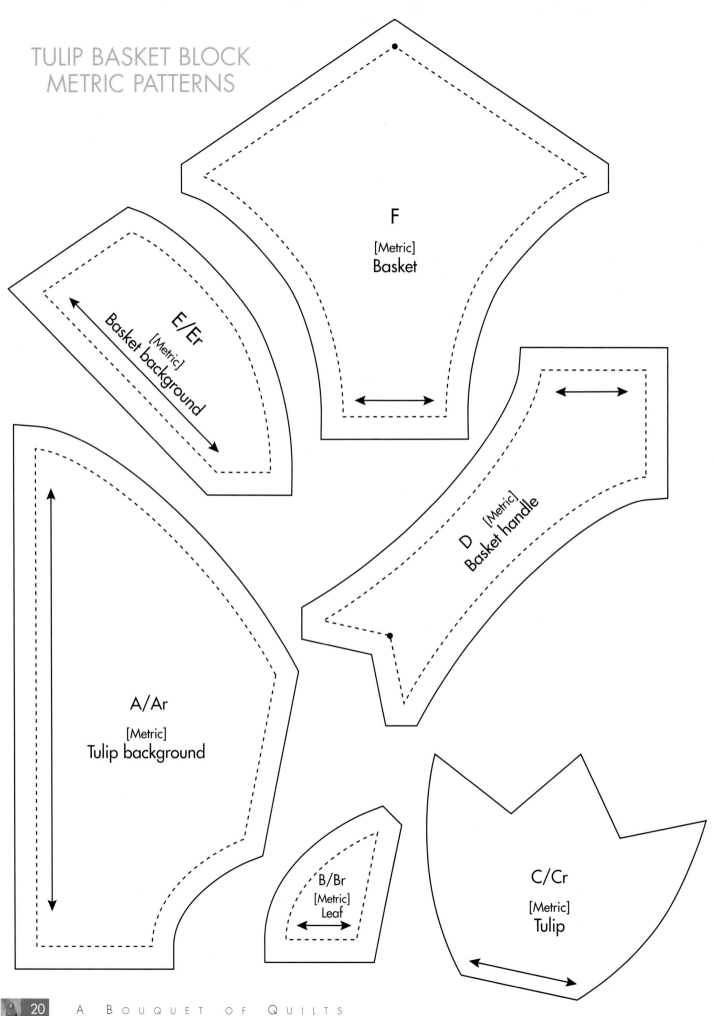

F

[Metric]
Basket

E/Er
[Metric]
Basket background

D [Metric]
Basket handle

A/Ar

[Metric]
Tulip background

B/Br
[Metric]
Leaf

C/Cr

[Metric]
Tulip

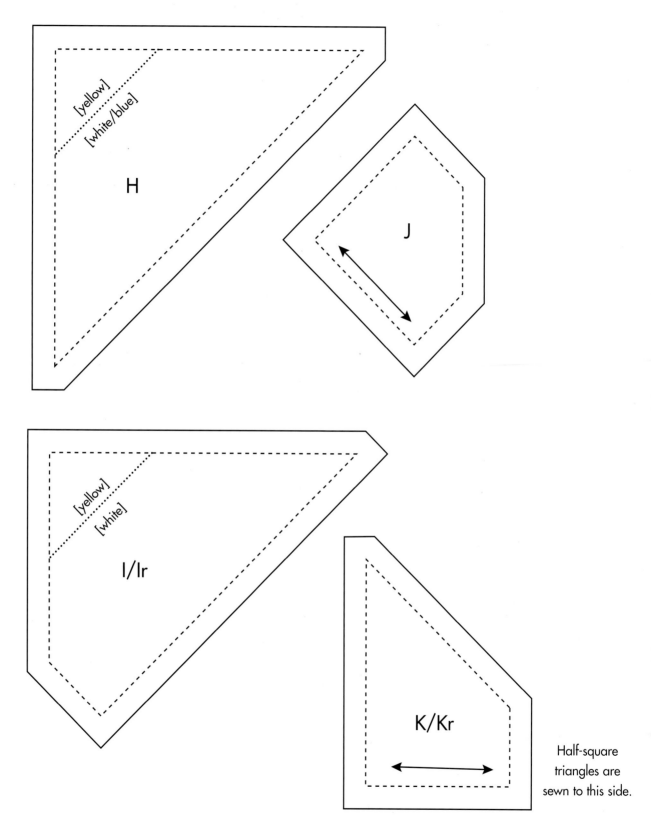

H

[yellow]
[white/blue]

J

I/Ir

[yellow]
[white]

K/Kr

Half-square
triangles are
sewn to this side.

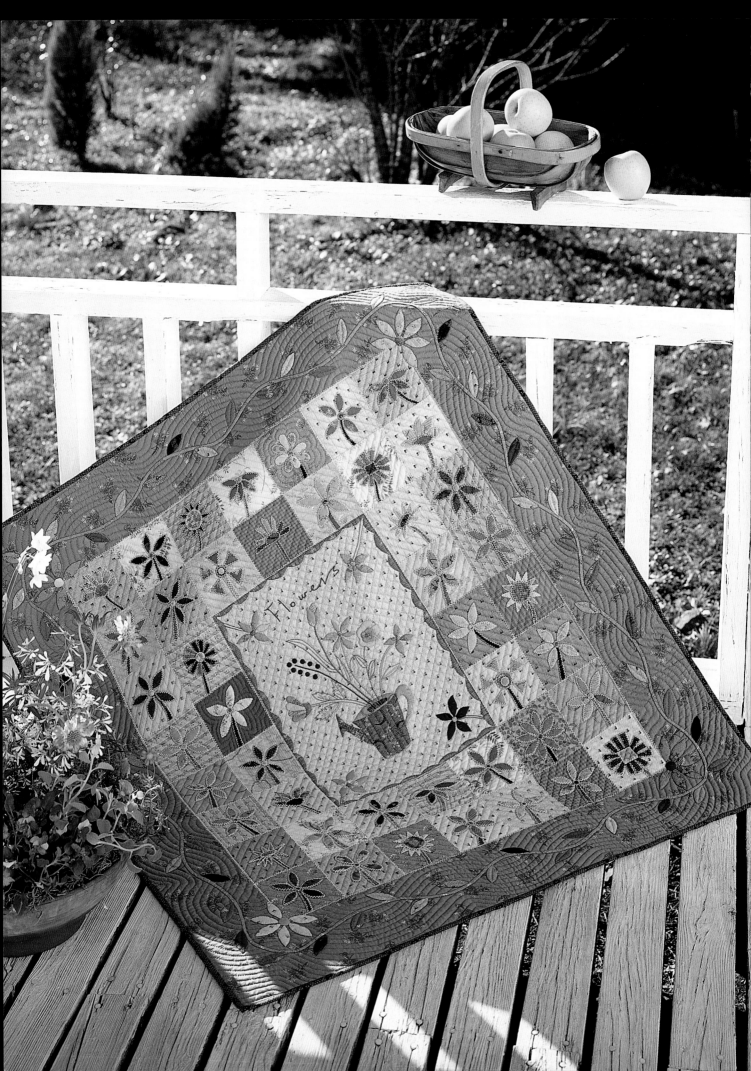

Watering Can Bouquet Sampler Quilt

Finished Size: 42" x 45½"" (106 cm x 117 cm)
Techniques: Piecing/Appliqué/Embroidery

Fabric and quilt designed by Yoko Saito
Photo by Akinori Miyashita

Watering Can Bouquet Sampler Quilt: Over a dozen blossoms surround a central medallion embellished with an old-fashioned watering can full of appliquéd and embroidered blooms. A graceful vine meanders through the wide border, while simple quilting motifs set off the folk-style flowers.

FABRIC REQUIREMENTS

U.S.		Metric
⅝ yard	Light background print	50 cm
2 yards total scraps	Burgundy, gold, green, light blue, gray, and tans for appliqué pieces	1.8 meters total scraps
¾ yard	Medium background print	60 cm
⅜ yard	Dark background print	30 cm
⅛ yard	Blue for inner border scallops	10 cm
⅞ yard (or 1¼ yards if you prefer to cut unpieced lengthwise strips for the border	Green for borders	75 cm (or 1.2 meters if you prefer to cut unpieced lengthwise strips for the border)
⅜ yard	Beige for border vine	35 cm
⅜ yard	Dark green for binding	30 cm
2 yards	Backing	2 meters
46" x 50"	Batting	116 cm x 127 cm
	Embroidery floss	

CUTTING

U.S.	Light background	Metric
15" x 19"	Center panel	37 cm x 48 cm
6" x 6" squares	9 squares	15 cm x 15 cm squares

NOTE: Use assorted scraps to cut out appliqué pieces for 48 flowers, the center panel bouquet, watering can, 60 leaves for the vine, and 4 large flowers for the corners.

U.S.		Metric
6" x 6" squares	24 medium background squares	15 cm x 15 cm squares
6" x 6" squares	11 dark background squares	15 cm x 15 cm squares
1/2" x 200"	Beige bias vine made using the 1/4" (6 mm) Clover bias tape maker	1.3 cm x 500 cm
⌒	36 blue inner border scallops	⌒

U.S.	Green	Metric
7" x 36"	Side borders: Cut 2.	18 cm x 92 cm
7" x 43"	Top and bottom borders: Cut 2.	18 cm x 109 cm

APPLIQUÉ AND EMBROIDERY

1. The center panel, block backgrounds, and borders are cut larger to allow for shrinkage when appliquéd. Using a marking pencil, lightly mark the finished dimensions of each background. These guidelines are useful for determining where to place the appliqué motifs. The center panel's finished size is $13^1/_8$" x $17^1/_2$" (33 cm x 44 cm). Each block's finished size is $4^3/_8$" x $4^3/_8$" (11 cm x 11 cm).

The two side borders' finished size is $5^1/_2$" x 35" (14 cm x 88 cm). The top and the bottom borders' finished size is $5^1/_2$" x $41^5/_8$" (14 cm x 105 cm).

2. Using assorted scraps and the appliqué method of your choice, appliqué the watering can (page 27) and the flowers (page 26) onto the center panel.

3. Appliqué the inner border scallops (page 26) along the marked finished edges of the center panel: ten on each side and eight each on the top and bottom. Line up the flat sewing line on the scallop with the marked line on the panel.

4. Embroider the greenery (page 26 and the lettering (page 27) of the center panel with a whipped stem stitch.

5. Place the center panel on top of a towel and press it on the wrong side. Trim it to measure $13^5/_8$" x 18" (34.2 cm x 45.2 cm), which includes seam allowances.

6. Using assorted scraps and the appliqué method of your choice, appliqué a flower design (pages 26–27) onto each of the 44 blocks.

7. Outline each appliqué piece with embroidered herringbone stitches.

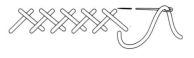

8. Trim each block to measure $4^7/_8$" x $4^7/_8$" (12.2 cm x 12.2 cm).

QUILT ASSEMBLY

1. To make each side panel, sew eight blocks together into two rows of four blocks each. Press seams open. Make two.

2. To make panels for the top and bottom sew fourteen blocks together into two rows of seven blocks each. Press seams open. Make two.

3. Embroider herringbone stitches along all of the seam lines.

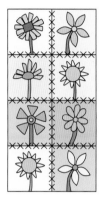

4. Sew the panels made in Step 1 to each side of the center panel. Press seams toward the center panel. Embroider herringbone stitches along all seam lines.

5. Sew the panels made in Step 2 to the top and bottom of the center panel section. Press seams open. Embroider herringbone stitches along all seam lines.

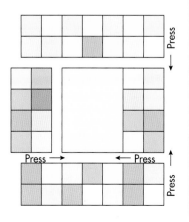

BORDERS

1. Appliqué the vine onto the borders, stopping approximately 6" (15 cm) from each end.

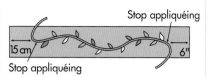

2. Randomly space and appliqué 13 or 14 leaves (page 26) onto each of the side borders and 14 to 16 leaves onto the top and bottom borders.

3. Measure the length of the quilt top through the center, and trim the side borders to this measurement x 6" (15.2 cm) wide. Sew side borders to the quilt top. Press seams toward the borders. Embroider herringbone stitches along the seam lines.

4. Measure the width of the quilt top through the center, including side borders, and trim the top and bottom borders to this measurement x 6" (15.2 cm) wide. Sew side borders to the quilt top. Press seams toward the borders. Embroider herringbone stitches along only the seam lines joining the appliqué blocks to the border.

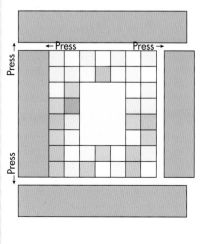

5. Finish appliquéing the vine onto the corners of the borders.

6. Appliqué a partial flower onto each inner corner of the border.

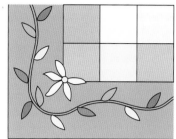

7. Carefully press the quilt top from the wrong side, pressing on top a bath towel to avoid crushing embroidery stitches.

FINISHING

Layer and baste the backing, batting, and quilt top.

All of the appliqué motifs in the center panel were outline quilted, and 1/2" (12 mm) wide diagonal cross-hatch grid was quilted in the background of the center panel. The appliqué motifs in the blocks and the borders are also outline quilted. The backgrounds of some appliqué blocks were echo-quilted, while the remainder of the blocks were quilted with diagonal lines 1/2" (12 mm) apart. The border was echo-quilted.

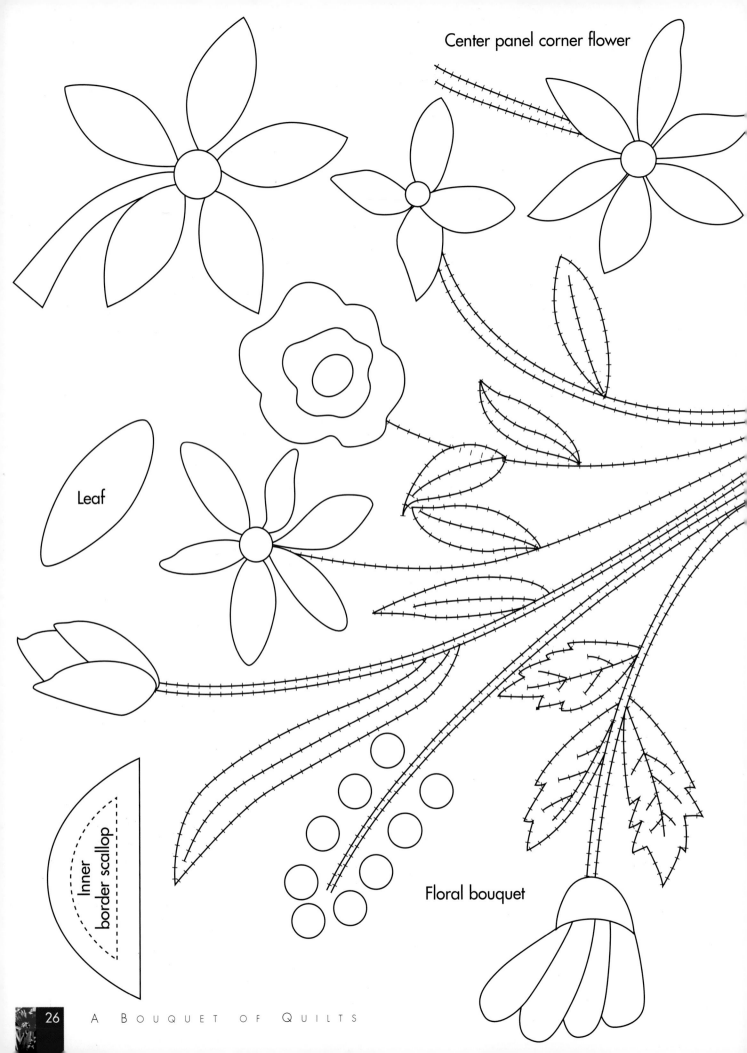

Center panel corner flower

Leaf

Inner border scallop

Floral bouquet

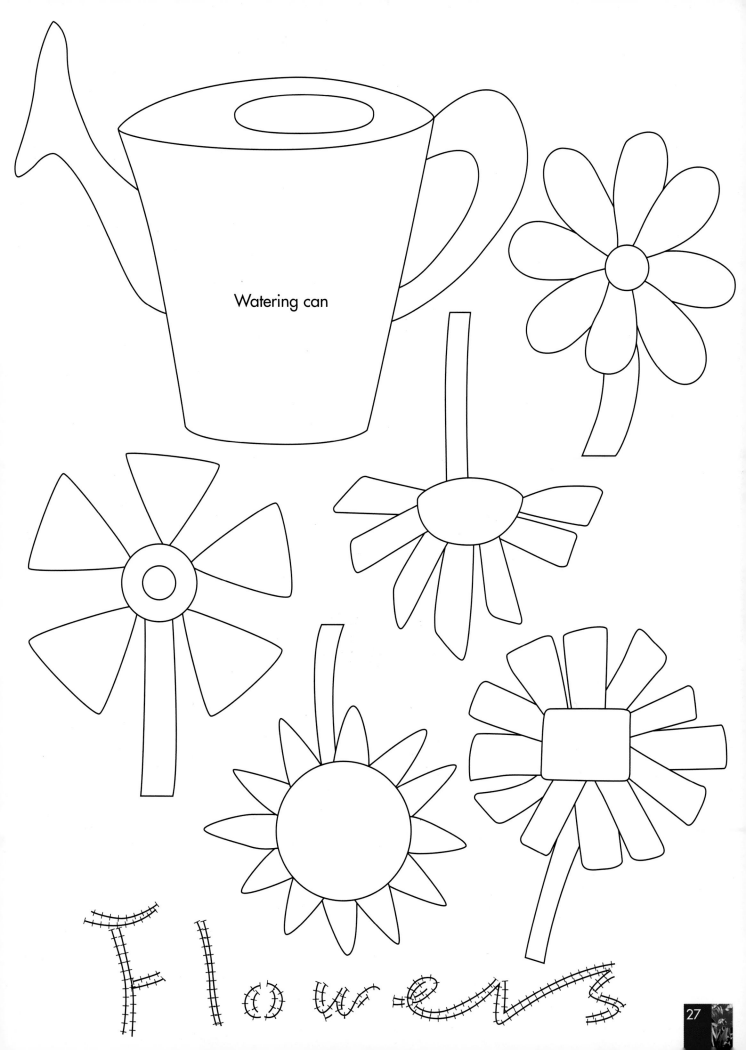

Watering can

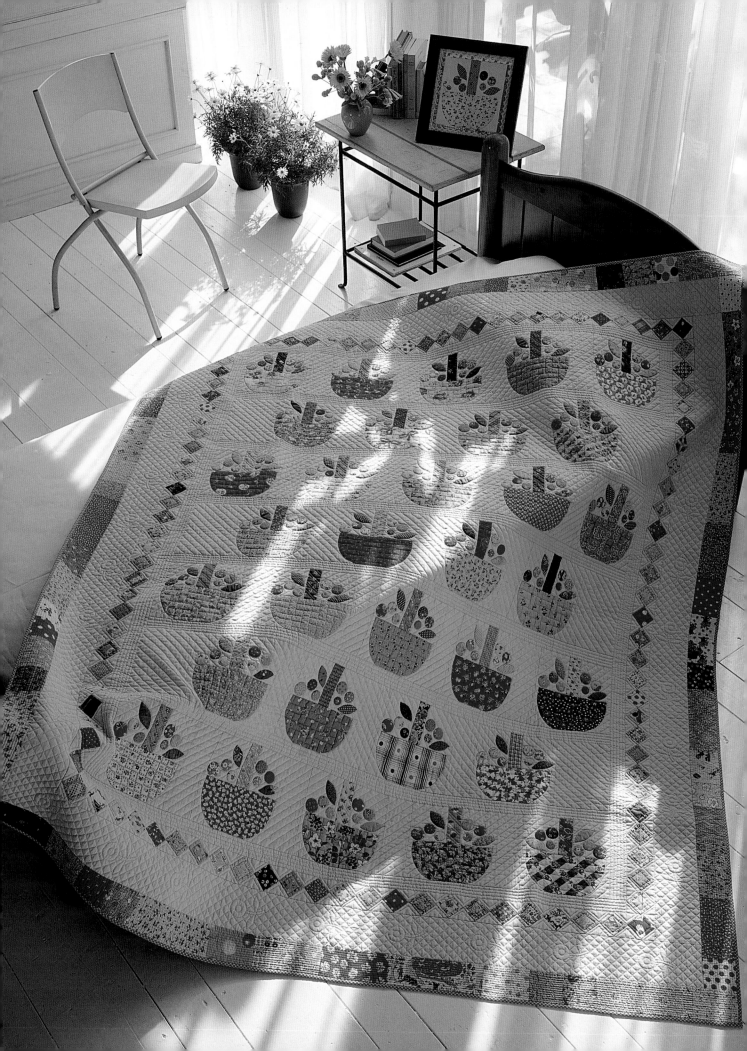

Buds in a Basket Quilt

Finished Size: 70" x 82¾" (178 cm x 214 cm)
Techniques: Piecing/Appliqué

Made by Sachiko Yasuda
Photo by Masaki Yamamoto

This dazzling quilt, which appeared on the cover of *Quilts Japan* (Issue 5, 2000), is the project that inspired our collaboration with Nihon Vogue. It shows us that the passion for reproduction 1930s and 40s fabrics and Provençal fabrics is an international phenomenon. *Buds in a Basket* is an ideal scrappy project for fabric collectors. Make one block and frame it for a lively decorative touch.

FABRIC REQUIREMENTS

U.S.		Metric
5⅜ yards	Background	4.6 meters
3⅜ yards	Assorted brights for the basket handles, baskets, leaves, circles, and borders	3.4 meters
½ yard	Binding	50 cm
5 yards	Backing	5 meters
75" x 90"	Batting	1.9 meters x 2.2 meters

CUTTING

U.S.	Background	Metric
3⅞" x 4½"	Background of basket handle: Cut 64.	9.7 cm x 11.2 cm
3" x 8½"	Narrow vertical sashing between basket blocks: Cut 25.	7.2 cm x 21.2 cm
5¾" x 8½"	Wide vertical sashing on each end of rows 2, 4, and 6: Cut 6.	14.2 cm x 21.2 cm

U.S.	Background	Metric
2" x 50½"	Horizontal sashing between basket rows: Cut 6.	4.7 cm x 125.2 cm
2" x 65½"	First side borders: Cut 2.	5.2 cm x 162.2 cm
2" x 53½"	First top and bottom borders: Cut 2.	5.2 cm x 133.2 cm
3⅜" x 3⅜" squares: Cut 58.	Pieced border: Cut each square diagonally into quarters (quarter-square triangles).	9.1 cm x 9.1 cm squares: Cut 51.
2" x 2" squares	Corners for pieced border: Cut 4 squares, then cut each square diagonally in half (half-square triangles).	5.2 cm x 5.2 cm squares
4" x 75"	Third side borders: Cut 2.	11.2 cm x 185 cm
4" x 70"	Third top and bottom borders: Cut 2.	11.2 cm x 170 cm
	Background of basket: Cut 32 B and 32 Br.	

U.S.	Assorted Brights	Metric
1¾" x 4½"	Basket handles: Cut nine 1¾" (4.2 cm) wide strips, then cut 32 pieces.	4.2 cm x 11.2 cm
	Leaves: Cut 64 C's.	
	Basket: Cut 32 A's.	
	Small circle: Cut 64 D's.	
	Medium circle: Cut 64 E's.	
	Large circle: Cut 64 F's.	
2" x 2" squares: Cut 118.	Pieced border	5.5 cm x 5.5 cm squares: Cut 104.
3¼" wide x various lengths	Final scrappy border	8.3 cm wide x various lengths

BLOCK ASSEMBLY

1. Sew one basket handle background to each side of the basket handle strip. Press seams toward the basket handle.

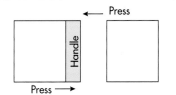

2. Using the appliqué method of your choice, appliqué one leaf and one of each size circle to each basket handle background.

3. Sew one basket background to each side of the baskets, matching dots. Note that the bottom and inside seam allowances of the basket background extend twice the standard seam-allowance width toward the basket and bottom of the block. This is to ease the fitting of this narrow angle. After sewing the basket backgrounds to the basket, press seams toward the basket. Trim excess basket background from the bottom of this piece, cutting even with the raw edge of the basket bottom.

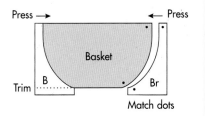

4. Sew basket units to the bottom of the handle units. Press seams toward the basket.

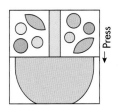

QUILT ASSEMBLY

1. Sew four rows of five basket blocks each, using narrow vertical sashing strips between blocks. Press seams toward sashings.

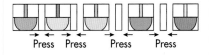

2. Sew three rows of four basket blocks each, using narrow vertical sashing strips between blocks. Sew one wide vertical sashing strip to each end of these rows. Press seams toward sashing.

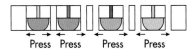

3. Alternately arrange the five- and four-block rows as shown. Sew rows together with long horizontal sashing strips between. Press seams toward sashings.

FIRST BORDER

1. Sew the first side borders to the sides of the quilt top. Press seams toward the borders.

2. Sew the first top and bottom borders to the quilt top. Press seams toward the borders.

PIECED BORDER

1. To make the pieced border, sew quarter-square background triangles to two opposite sides of 110 (96) bright 2" x 2" (5.5 cm x 5.5 cm) squares. Press seams toward the squares.

2. Sew these units together to make two strips of 24 (21) units each and two strips of 31 (27) units each. Press seams in one direction.

3. Sew one quarter-square triangle and one half-square triangle to opposite sides of four bright 2" x 2" (5.5 cm x 5.5 cm) squares. Press seams toward the squares.

Make 4

4. Sew one of these units to one end of each of the strips made in Step 2. Press.

5. Sew one of the longer pieced borders to the left side of the quilt top, so the bright square with the half-square triangle matches the upper left-hand corner of the top. Press the seam toward the first plain border.

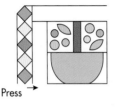

Press →

6. Sew one of the shorter pieced borders to the upper edge of the quilt top, so the bright square with the half-square triangle matches the upper right-hand corner of the quilt top. At the left-hand corner, the border creates a diagonal edge with the side border. Press seams toward the first plain border.

Press ↓

7. Repeat Steps 5 and 6, sewing the two remaining pieced borders to the quilt top.

8. Sew two quarter-square triangles to opposite sides of the four remaining bright 2" x 2" (5.5 cm x 5.5 cm) squares. Press seams toward the square.

Half-square triangle ←

Make 4

9. Sew one half-square triangle to a third side of the square. Press the seam toward the square.

10. Sew these corner units to the corners of the quilt top. Press seams toward the corner units.

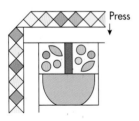

Press

THIRD BORDER

1. Measure the quilt top lengthwise through the center and trim the two side borders to this size. Sew the third side borders to your quilt top. Press the seams toward these borders.

2. Measure the quilt top through the center including the side borders, and trim the top and bottom borders to this size. Sew the third top and bottom borders onto your quilt top. Press the seams toward these borders.

FINAL SCRAPPY BORDER

1. Sew together the 3¹⁄₄" (8.3 cm) wide rectangles into two strips, each approximately 75" (203 cm) long for the top and bottom borders, and 85" (220 cm) long for the two side borders.

2. Measure the quilt top lengthwise through the center, and trim the two side borders to this size. Sew the final scrappy side borders to your quilt top. Press seams toward these borders.

3. Measure the width of the quilt top through the center, including the side borders, and trim the top and bottom strips to this size. Sew the final scrappy top and bottom borders to the quilt top. Press seams toward these borders.

FINISHING

Layer and baste the backing, batting, and quilt top.

All of the appliqué pieces are outline quilted, while pairs of diagonal lines were quilted in the basket handles. The lines of each pair are ¹⁄₄" (6 mm) apart and each pair is ⁵⁄₈" (1.6 cm) apart. A basketweave pattern was quilted in the basket. The background of each block was quilted with diagonal lines that run in the opposite direction from the lines quilted in the basket handles. The sashing strips were quilted with rows of lines ³⁄₈" (1 cm) apart, running the length of the strips. Each piece of the pieced border was quilted ⁵⁄₈" (1.6 cm) away from the seam lines. The scrappy border was quilted with a floral motif and a background grid that is ⁵⁄₈" (1.6 cm) wide. The final border was quilted with rows of lines ¹⁄₄" (6 mm) apart that run parallel to the edge of the quilt.

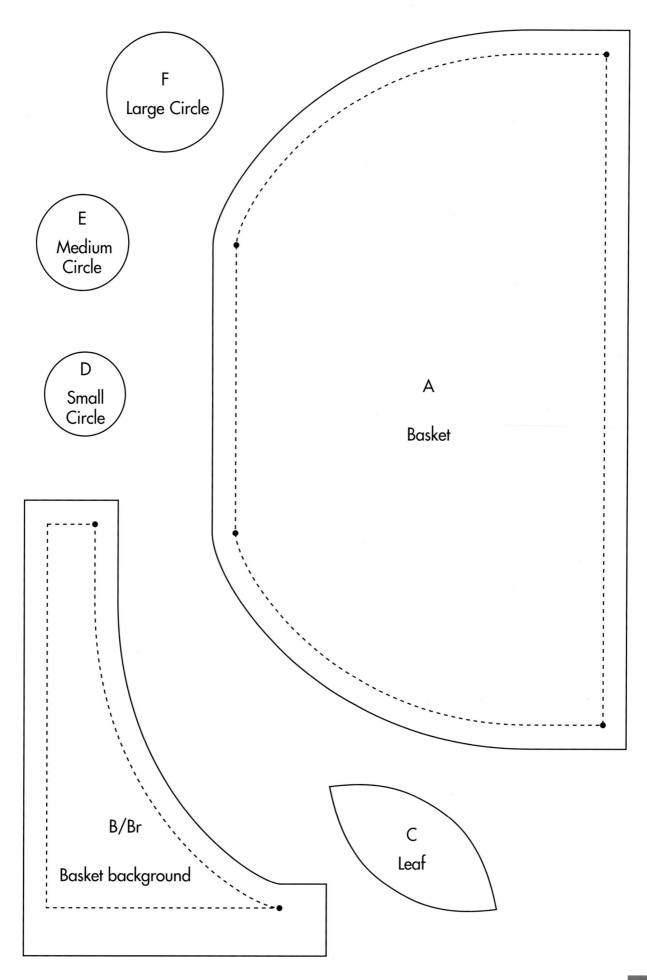

F
Large Circle

E
Medium
Circle

D
Small
Circle

A

Basket

B/Br

Basket background

C
Leaf

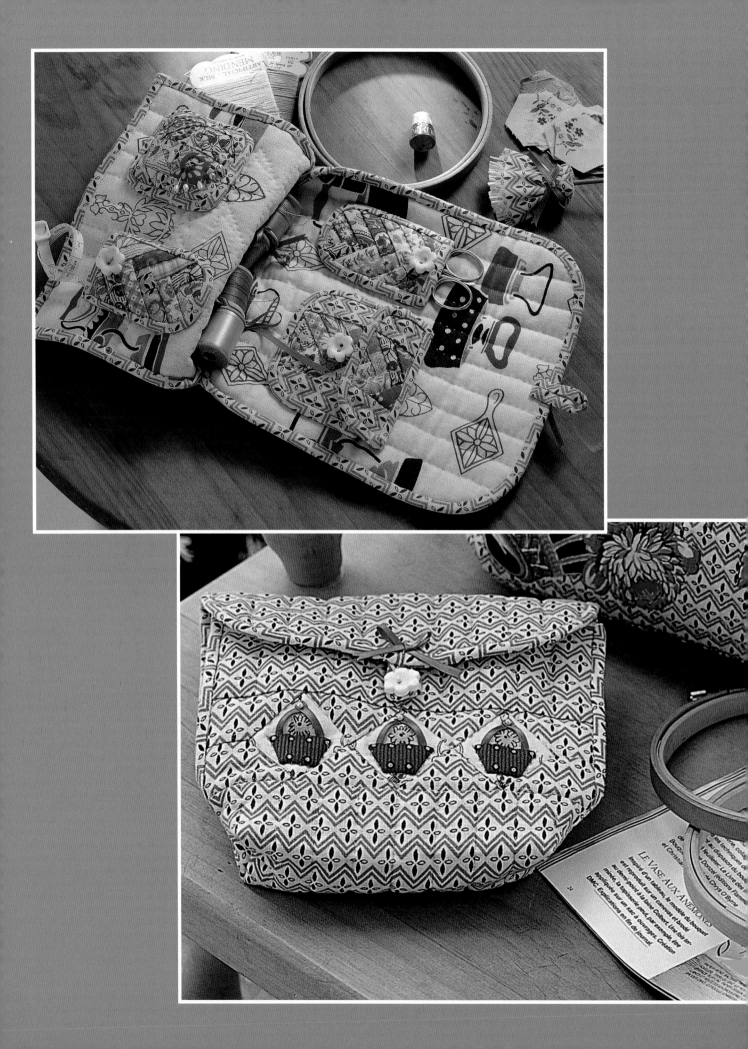

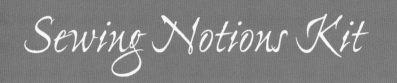

Sewing Notions Kit

Finished Size: 7" wide x 5½" high x 1½" deep (18 cm wide x 14 cm high x 4 cm deep)
Techniques: Traditional/Paper piecing

Made by Mieko Matsuda
with Yoko Ishiyama
Photo by Masaki Yamamoto

Need a special gift for a sewing enthusiast or a fun project for a quilt group? Pretty and portable, this sewing kit is a great way to store tools and notions for projects on the go.

FABRIC REQUIREMENTS

U.S.		Metric
⅝ yard	Blue print for front, pockets, and bias binding	50 cm
⅛ yard total	Red, pink, and blue scraps for pieced pockets and appliqué	10 cm total
¼ yard	Lining (inside of kit)	20 cm
⅛ yard	Muslin	10 cm
16" x 16"	Batting	40 cm x 40 cm
1⅝ yards of ⅛" wide	Ribbon	1.4 meters of 3 mm wide
¾"	2 buttons	18 mm
	3 pearl beads, 2 mm	
	Small amount of stuffing for pincushion	

CUTTING

U.S.	Blue prints	Metric
One 18" x 18" square	Bias binding	One 40 cm x 40 cm square
7½" x 11½"	Front of kit: Cut 1.	19.2 cm x 29.2 cm
3" x 7½"	Front of kit: Cut 1.	7.4 cm x 19.2 cm
⬡	Cut 2 B and 2 Br.	⬡
3" x 3" square	One square. Cut into quarters diagonally.	7.7 cm x 7.7 cm square
1" x 4¾"	Button loop	2.5 cm x 12 cm
1¼" x 2¾"	Wide pocket sides: Cut 2 for 10 and 11.	3.1 cm x 7 cm
1¼" x 1¾"	Wide pocket flap sides: Cut 2 for 8 and 9.	3.1 cm x 4.5 cm
1⅝" x 1⅝" squares	Pincushion background: Cut 4 squares. Cut each in half diagonally.	4 cm x 4 cm squares
⅞" x ⅞" squares	Pincushion: Cut 8.	2.2 cm x 2.2 cm squares

U.S.	Scraps	Metric
1¾" x 1¾" squares	Background for basket appliqué on outside of kit: Cut 3.	4.4 cm x 4.4 cm squares
⬯	Appliqué basket (A): Cut 3.	⬯
1⅝" x 1⅝" squares	Pincushion baskets: Cut 4 squares. Cut each in half diagonally; you will have 4 extra triangles to use for paper piecing the pockets.	4 cm x 4 cm squares
1¼" x 1¼" squares	Pincushion baskets: Cut 4 squares. Cut each in half diagonally.	3.2 cm x 3.2 cm squares

NOTE : Additional scraps will be needed to paper piece
the pocket chevrons.

U.S.	Lining	Metric
7½" x 15¾"	Inside of kit	19.2 cm x 40 cm
(rounded square shape)	Back of pincushion	(rounded square shape)

U.S.	Muslin	Metric
2¼" x 3¼"	Lining for narrow pockets: Cut 2.	5.5 cm x 8 cm
2¾" x 3⅝"	Lining for wide pocket: Cut 1.	7 cm x 9 cm
1⅞" x 3⅝"	Lining for wide pocket flap: Cut 1.	4.5 cm x 9 cm
2¾" x 2¾" square	Lining for pincushion: Cut 1.	7.2 cm x 7.2 cm square

U.S.	Batting	Metric
7½" x 15¾"	Body of kit	19.2 cm x 40 cm
2⅞" x 2⅞"	Pincushion	7.2 cm x 7.2 cm
2¼" x 3¼"	Narrow pockets: Cut 2.	5.5 cm x 8 cm
2¾" x 3⅝"	Wide pocket	7 cm x 9 cm
1⅞" x 3⅝"	Wide pocket flap	4.5 cm x 9 cm

U.S.	Ribbon	Metric
16"	Ties for thread spools: Cut 2.	40 cm
2½"	Button loop for pocket flap	6.4 cm
12"	Bow for outside of kit	30 cm
3"	Handles for the appliquéd baskets: Cut 3.	7 cm

PIECED AND APPLIQUÉD OUTSIDE STRIP

1. Using the appliqué method of your choice, sew one basket to each of the three 1³/₄" x 1³/₄" (4.4 cm x 4.4 cm) basket appliqué background squares. Before sewing the top of the basket in place, tuck in the ends of the 3" (7 cm) ribbon. Twist the ribbon to form the basket handle and sew one bead to hold the handle in place. Arrange the background fabric so a floral motif appears just above the appliquéd basket, if desired.

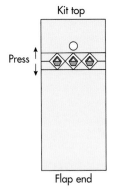

2. Arrange the three basket blocks on point with four quarter-square triangles, two B's and two Br's. Sew quarter-square triangles to basket blocks. Press seams toward the triangles.

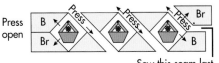

3. Sew a B and a Br to the outer basket blocks, stopping and starting sewing at the dot, ¹/₄" (6 mm) from the corner, as shown.

4. Sew between B and Br, starting at the dot and sewing to the end of the seam. Press the seam open.

5. Sew the three Basket block units together. Press carefully.

FRONT OF KIT ASSEMBLY

1. Sew the 3" x 7¹/₂" (7.4 cm x 19.2 cm) piece of blue print to the top of the basket strip. Press the seam away from the basket strip.

2. Sew the 7¹/₂" x 11¹/₂" (19.2 cm x 29.2 cm) piece of blue fabric to the bottom of the basket strip. Press the seam away from the basket strip.

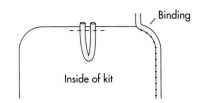

3. Layer the outside of the kit on top of the batting and the inside lining. Baste and outline quilt in the appliquéd basket strip. Quilt lengthwise parallel lines, ³/₄" (1.9 cm) apart, on the remainder of the kit.

4. Using the corner curve pattern, cut the top corners.

5. Sew a scant ¹/₄" (6 mm) away from all outer edges.

6. Fold the long edges of the button loop into the center, wrong sides together. Then fold the loop in half lengthwise, and hand sew the folded edges closed.

7. Fold the loop in half and baste it to the center of the inside flap end, matching the raw edges.

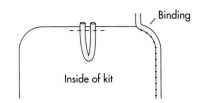

8. From the 18" x 18" (40 cm x 40 cm) square, make a continuous 2" (5 cm) wide bias strip for the binding. Bind the raw edges of the kit.

POCKETS

1. Use the paper-piecing patterns on page 40 to make the front of the pockets.

2. Layer each of the pockets with batting and muslin and quilt in-the-ditch.

3. Sew a scant ¹/₄" (6 mm) away from all outer edges.

4. Fold, center, and baste the 2¹/₂" (6.4 cm) length of ribbon to the wide pocket flap, matching raw edges. (Refer to Front of Kit Assembly, Step 7.)

5. Bind the raw edges of all of the pocket parts with the continuous bias binding.

PINCUSHION

1. To make the basket handles, cut four ³/₈" x 1³/₈" (1 cm x 3 cm) bias strips from scraps that match the pincushion baskets.

2. Turn under the long edges a scant ¹/₈" (3 mm), just as you did for the loop in Front of Kit Assembly, Step 6.

3. Appliqué the basket handles to four of the 1⅝" (4 cm) blue print half-square triangles. Or, for ease of handling, baste the handles in place until after the pincushion is pieced.

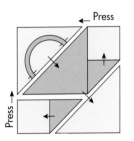

4. Sew each of the Step 3 units to a matching 1⅝" (4 cm) half-square scrap triangle. Press seams away from the handle triangle.

5. Sew one ⅞" (2.2 cm) blue print square to each 1¼" (3.2 cm) half-square scrap triangle. Press toward the square.

6. Sew the Step 5 units to each side of the Step 4 units. Press seams toward large triangles.

7. Sew the remaining 1⅝" (4 cm) blue print half-square triangles to Step 6 units made to complete the baskets. Press seams toward the blue-print triangle.

8. Sew the four baskets together with handles in the center. Press seams open. Finish appliquéing the handles if you haven't already done so.

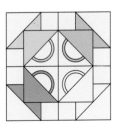

9. Layer the pincushion top with batting and muslin and quilt in-the-ditch.

10. Sew a scant ¼" (6 mm) away from the outer edges. Trim excess batting. Using the Back of pincushion pattern, cut the pincushion to size.

11. Sew the lining to the back of the pincushion top, wrong sides together, leaving an opening on one side.

12. Fill the pincushion with the stuffing, and sew the opening closed.

13. Bind all raw edges with the continuous bias strip.

FINISHING

1. Hand sew the pockets and pincushion to the lining side of the kit.

2. With the outer (blue print) sides of the kit together, fold the kit 9" (23 cm) down from the top.

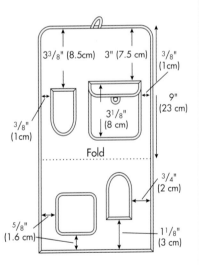

3. Machine sew 1⅝" (4 cm) along the inner edge of the binding on both sides of the kit.

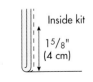

4. To make the spool pocket, open up the kit so the seam line lies centered along the fold made in Step 2. Machine sew straight across each corner, ⅞" (2 cm) from the point.

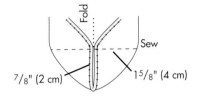

5. Trim the seam ⅜" (1cm) away from the machine sewing.

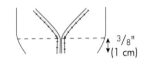

6. Bind the raw edge with the continuous bias strip, tucking in the ends of the 16" (40 cm) lengths of ribbon for the thread spool ties on the edges of the kit.

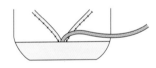

7. Make a bow from the 12" (30 cm) length of ribbon, and sew it to the outside center of the kit's flap end.

8. Sew a button just above the middle appliquéd basket on the outside of the kit and to the center of the wide pocket inside the kit so the ribbon loops can reach them.

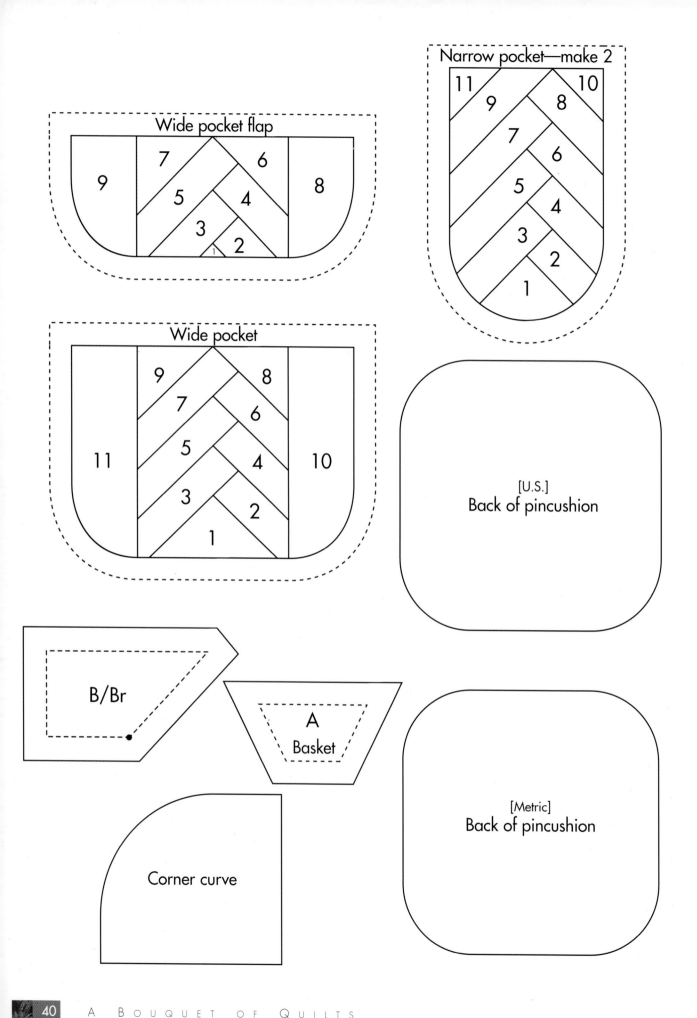

Wide pocket flap

9 7 6 5 4 3 2 1 8

Narrow pocket—make 2

11 10 9 8 7 6 5 4 3 2 1

Wide pocket

9 8 7 6 5 4 3 2 1 11 10

[U.S.]
Back of pincushion

B/Br

A
Basket

Corner curve

[Metric]
Back of pincushion

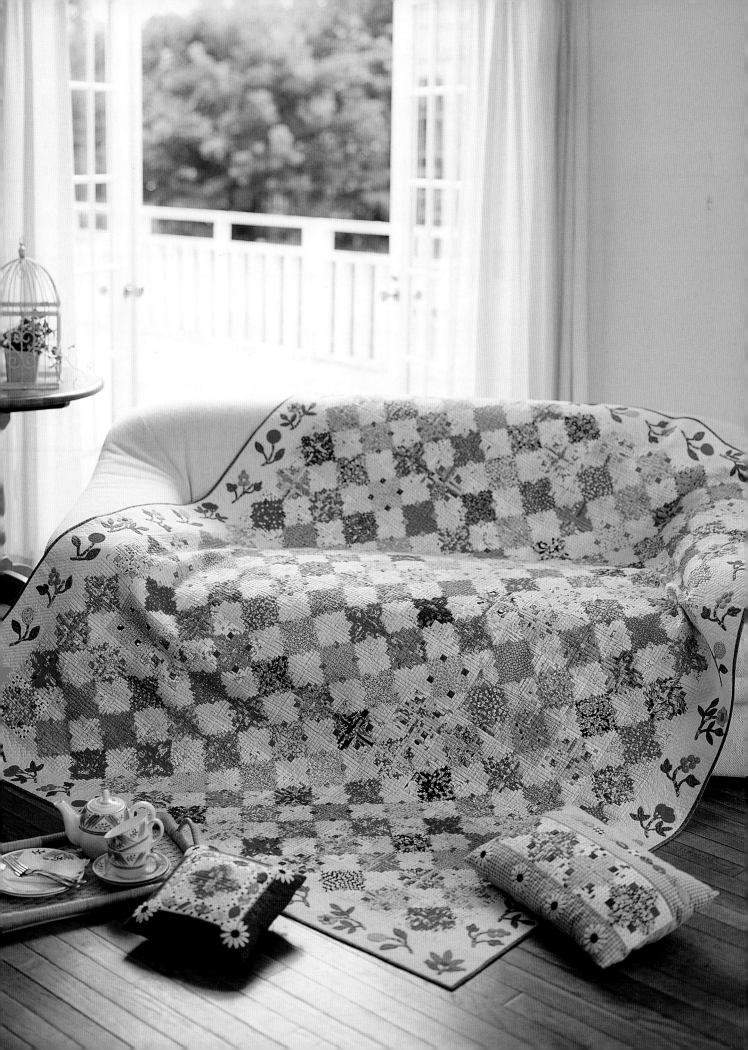

Rainbow Garden Log Cabin Quilt

Finished Size: 62¾" x 80¾" (159 cm x 204 cm)
Techniques: Paper piecing/Appliqué

Made by Sachiko Obata
Photo by Norio Ando

This fabulous paper-pieced Log Cabin project with eye-catching color is dynamic with the addition of the floral appliqué border. The original pattern, which follows, uses blocks made from four 2¼" (5.7 cm) paper-pieced Log Cabin blocks, creating a stunning visual impact. Those who want to tackle the project on a larger scale can follow instructions for 4" (10.2 cm) paper-pieced units that combine to make 8" (20.3 cm) blocks. Directions begin on page 46.

FABRIC REQUIREMENTS

U.S.		Metric
1⅜ yards total scraps	Brights for chimneys	1.3 meters total scraps
8 yards total	Brights for logs	8.5 meters total
7¼ yards total	Lights for logs	7.7 meters total
1¼ yards (or 2¼ yards if you prefer to cut unpieced lengthwise strips for the border; use the remainder for the light logs)	Border	1.1 meters (or 1.9 if you prefer to cut unpieced lengthwise strips for the border; use the remainder for the light logs)
¼ yard total	Browns for stems	25 cm total
⅝" yard total	Greens for leaves	55 cm total
1 yard total scraps	Floral motifs	90 cm total
½ yard	Green for binding	41 cm
5 yards	Backing	4.4 meters
67" x 85"	Batting	170 cm x 214 cm

CUTTING

U.S.	Brights	Metric
1½" x 1½" squares	Chimney: Cut 768.	4 cm x 4 cm squares
1" x 1¾"	Log 4: Cut 768.	3 cm x 5 cm
1" x 2"	Log 5: Cut 768.	3 cm x 5 cm
1" x 2¼"	Log 8: Cut 768.	3 cm x 5.5 cm
1" x 2½"	Log 9: Cut 768.	3 cm x 6.5 cm
1" x 2¾"	Log 12: Cut 768.	3 cm x 7 cm
1" x 3"	Log 13: Cut 768.	3 cm x 7.5 cm

U.S.	Lights	Metric
1" x 1½"	Log 2: Cut 768.	3 cm x 4 cm
1" x 1¾"	Log 3: Cut 768.	3 cm x 4.5 cm
1" x 2"	Log 6: Cut 768.	3 cm x 5 cm
1" x 2¼"	Log 7: Cut 768.	3 cm x 5.5 cm
1" x 2½"	Log 10: Cut 768.	3 cm x 6.5 cm
1" x 2¾"	Log 11: Cut 768.	3 cm x 7 cm
6" x 73½"	Side borders: Cut 2.	15 cm x 186 cm
6" x 64"	Top and bottom borders: Cut 2.	15 cm x 163 cm

NOTES: Use assorted scraps to cut out appliqué pieces
for 52 flowers for the borders.

Borders are cut approximately ¹/₂" (12 mm) larger than
necessary on all sides to allow for shrinkage during appliqué.

BLOCK ASSEMBLY

1. Make 768 copies of the Log Cabin pattern for paper piecing.

2. Make 192 sets of four matching Log Cabin squares. Logs 2, 3, 6, 7, 10 and 11 are light-colored fabrics. Logs 4, 5, 8, 9, 12 and 13 are bright-colored fabrics.

3. Sew each set of four matching Log Cabin blocks together with their bright-colored fabrics meeting in the center. Press carefully with a dry iron.

Make 192

4. Arrange the blocks into 16 rows of 12 blocks each. Press your top carefully with a dry iron.

BORDERS

1. Using the appliqué method of your choice, appliqué 14 flowers to each side border and 12 flowers each to the top and bottom borders.

2. Measure the length of the quilt top through the center, and trim the side borders to this measurement x $4^7/_8$" (12.4 cm) wide. Sew the side borders to the quilt top. Press the seams toward the borders.

3. Measure the width of the quilt top through the center, including the side borders, and trim the top and bottom borders to this measurement x $4^7/_8$" (12.4 cm) wide. Sew top and bottom borders to the quilt top. Press seams toward the borders.

QUILTING

Layer and baste the backing, batting, and quilt top.

Quilt the blocks in-the-ditch and add diagonal lines $5/_{16}$" (8 mm) apart in the borders.

Make 16 rows.

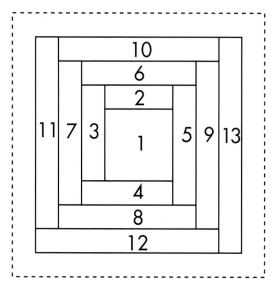

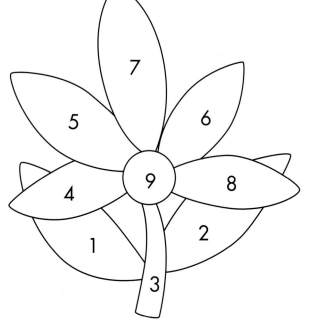

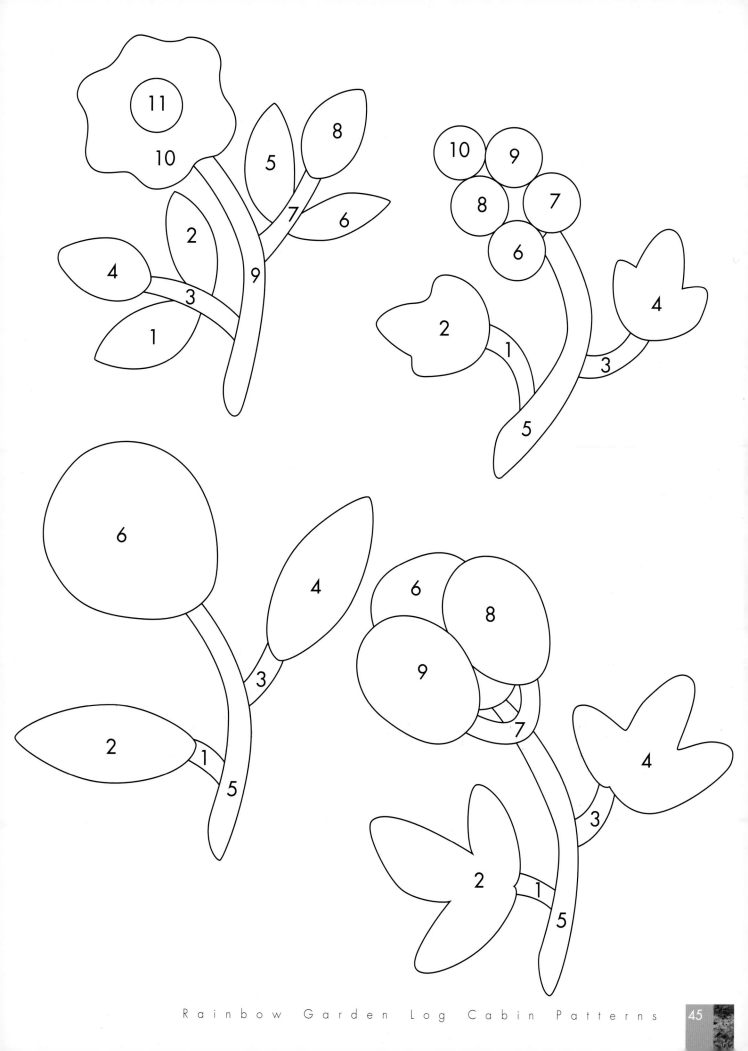

Finished Size: 56³/₄" x 72³/₄" (144 cm x 185 cm)
Techniques: Paper piecing/Appliqué

FABRIC REQUIREMENTS

U.S.		Metric
¹/₂ yard total	Brights for chimneys	41 cm total
3⁷/₈ yards total	Brights for logs	3.5 meters total
3³/₈ yards total	Lights for logs	3 meters total
1¹/₄ yards (or 1⁷/₈ yards if you wish to cut the borders without seams; use the remainder for light logs)	Border	1.1 meters (or 1.7 meters if you wish to cut the borders without seams; use the remainder for light logs)
¹/₄ yard total	Browns for stems	25 cm total
⁵/₈ yard total	Greens for leaves	55 cm total
1 yard total	Floral motifs	90 cm total
¹/₂ yard	Green for binding	40 cm
3¹/₂ yards	Backing	3.2 meters
61" x 77"	Batting	155 cm x 196 cm

CUTTING

U.S.	Brights	Metric
1¾" x 1¾" squares	Chimney: Cut 192.	4.5 cm x 4.5 cm squares
1¼" x 2¼"	Log 4: Cut 192.	3 cm x 6 cm
1¼" x 2¾"	Log 5: Cut 192.	3 cm x 7 cm
1¼" x 3¼"	Log 8: Cut 192.	3 cm x 8.5 cm
1¼" x 3¾"	Log 9: Cut 192.	3 cm x 9.5 cm
1¼" x 4¼"	Log 12: Cut 192.	3 cm x 11 cm
1¼" x 4¾"	Log 13: Cut 192.	3 cm x 12 cm

U.S.	Lights	Metric
1¼" x 1¾"	Log 2: Cut 192.	3 cm x 4.5 cm
1¼" x 2¼"	Log 3: Cut 192.	3 cm x 6 cm
1¼" x 2¾"	Log 6: Cut 192.	3 cm x 7 cm
1¼" x 3¼"	Log 7: Cut 192.	3 cm x 8.5 cm
1¼" x 3¾"	Log 10: Cut 192.	3 cm x 9.5 cm
1¼" x 4¼"	Log 11: Cut 192.	3 cm x 11 cm
6" x 65½"	Side borders: Cut 2	15 cm x 166 cm
6" x 58"	Top and bottom borders: Cut 2.	15 cm x 148 cm

NOTES: Use assorted scraps to cut out appliqué pieces for 46–48 flowers for the borders.

Borders are cut approximately ½" (12 mm) larger than necessary on all sides to allow for shrinkage during appliqué.

BLOCK ASSEMBLY

1. Make 192 copies of the Log Cabin pattern for paper piecing.

2. Make 48 sets of four matching Log Cabin squares. Logs 2, 3, 6, 7, 10, and 11 are light-colored fabrics. Logs 4, 5, 8, 9, 12, and 13 are bright-colored fabrics.

3. Sew each set of four matching Log Cabin blocks together with their bright-colored fabrics meeting in the center. Press carefully with a dry iron.

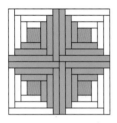

4. Arrange the blocks in 8 rows of 6 blocks each. Press the top carefully with a dry iron.

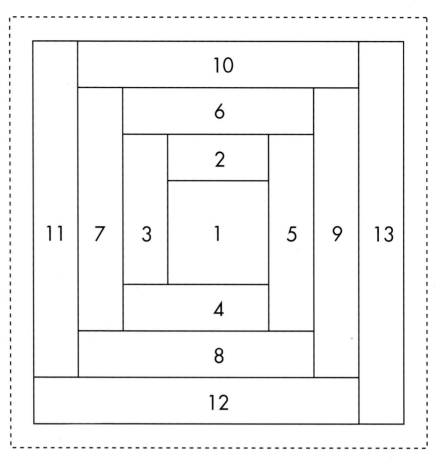

BORDERS

1. Using the appliqué method of your choice appliqué 12 flowers to each side border and 11–12 flowers each to the top and bottom borders.

2. Follow the instructions on page 44 for border assembly.

FINISHING

Follow the instructions on page 44.

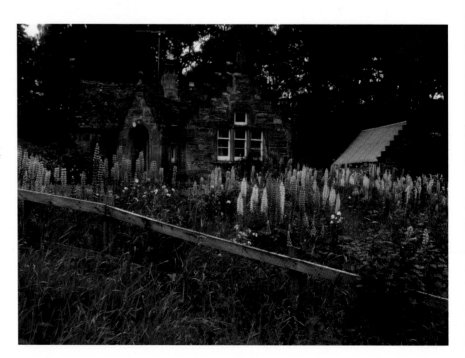

Rainbow Garden
Log Cabin Pillow

Finished Size: 12 1/2" x 12 1/2" (31.2 cm wide x 31.2 cm)

Techniques: Paper piecing/Appliqué

Fun to make and perfect for brightening up any decorating scheme, this pillow uses a variety of techniques: the 2 1/4"-square paper-pieced Log Cabin blocks are set within an appliquéd border. Purchased daisies embellish the corners.

FABRIC REQUIREMENTS

U.S.		Metric
1/8 yard total	Lights for logs	10 cm total
1/8 yard total	Brights for chimneys and logs	15 cm total
1/8 yard	Inner border	10 cm
1/4 yard	Outer border	20 cm
1 1/4 yards	Rickrack	80 cm
1 1/2" round	Purchased embroidered daisies: 4	4 cm round
3/8 yard	Backing	35 cm
12" x 12" square	Pillow form	31 cm x 31 cm square

CUTTING

U.S.	Lights	Metric
1" x 1½"	Log 2: Cut 4.	3 cm x 4 cm
1" x 1¾"	Log 3: Cut 4.	3 cm x 4.5 cm
1" x 2"	Log 6: Cut 4.	3 cm x 5 cm
1" x 2¼"	Log 7: Cut 4.	3 cm x 5.5 cm
1" x 2½"	Log 10: Cut 4.	3 cm x 6.5 cm
1" x 2¾"	Log 11: Cut 4.	3 cm x 7 cm

U.S.	Brights	Metric
1½" x 1½" squares	Chimney: Cut 4.	4 cm x 4 cm squares
1" x 1¾"	Log 4: Cut 4.	3 cm x 4 cm
1" x 2"	Log 5: Cut 4.	3 cm x 5 cm
1" x 2¼"	Log 8: Cut 4.	3 cm x 5.5 cm
1" x 2½"	Log 9: Cut 4.	3 cm x 6 cm
1" x 2¾"	Log 12: Cut 4.	3 cm x 6.5 cm
1" x 3"	Log 13: Cut 4.	3 cm x 7.5 cm
⬡	16	⬡

U.S.	Inner Border	Metric
2⅛" x 5"	Side borders: Cut 2.	5.2 cm x 12.6 cm
2⅛" x 8¼"	Top and bottom borders: Cut 2.	5.2 cm x 20.6 cm

U.S.	Outer Border	Metric
2⁷/₈" x 8¹/₄"	Side borders: Cut 2.	7.2 cm x 20.6 cm
2⁷/₈" x 13"	Top and bottom borders: Cut 2.	7.2 cm x 32.6 cm

U.S.		Metric
13" x 13" square	Backing	32.6 cm x 32.6 cm square

BLOCK ASSEMBLY

1. Make four copies of the 2¹/₄" (5.7 cm) Log Cabin pattern (page 44) for foundation piecing.

2. Make four matching Log Cabin blocks. Logs 2, 3, 6, 7, 10, and 11 are light-colored fabrics. Logs, 4, 5, 8, 9, 12, and 13 are bright-colored fabrics.

3. Sew the Log Cabin blocks together with their bright-colored fabrics meeting in the center. Press the blocks carefully with a dry iron.

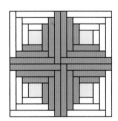

4. Sew the side inner borders to the pillow top. Press seams toward the borders.

5. Sew the top and bottom inner borders to the pillow top. Press seams toward the borders.

6. Sew the side outer borders to the pillow top. Press seams toward the outer borders.

7. Sew the top and bottom outer borders to the quilt top. Press seams toward the outer borders.

8. Sew rickrack along seams between inner and outer borders.

9. Using the appliqué method of your choice, evenly space and appliqué four of the appliqué shapes along each inner border. Press carefully.

10. Sew one purchased, embroidered daisy on each corner of the outer border.

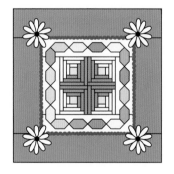

FINISHING

While the original pillow top does not appear to be quilted, you can add your favorite quilting designs if desired.

1. Layer the pillow top with the backing, right sides together. Start sewing about 2" (5 cm) from one corner and finishing 2" (5 cm) away from the other corner on the same side.

2. Trim the corners. Turn the pillow right side out, and press carefully.

3. Insert the pillow form, and hand sew the opening closed.

Make 16

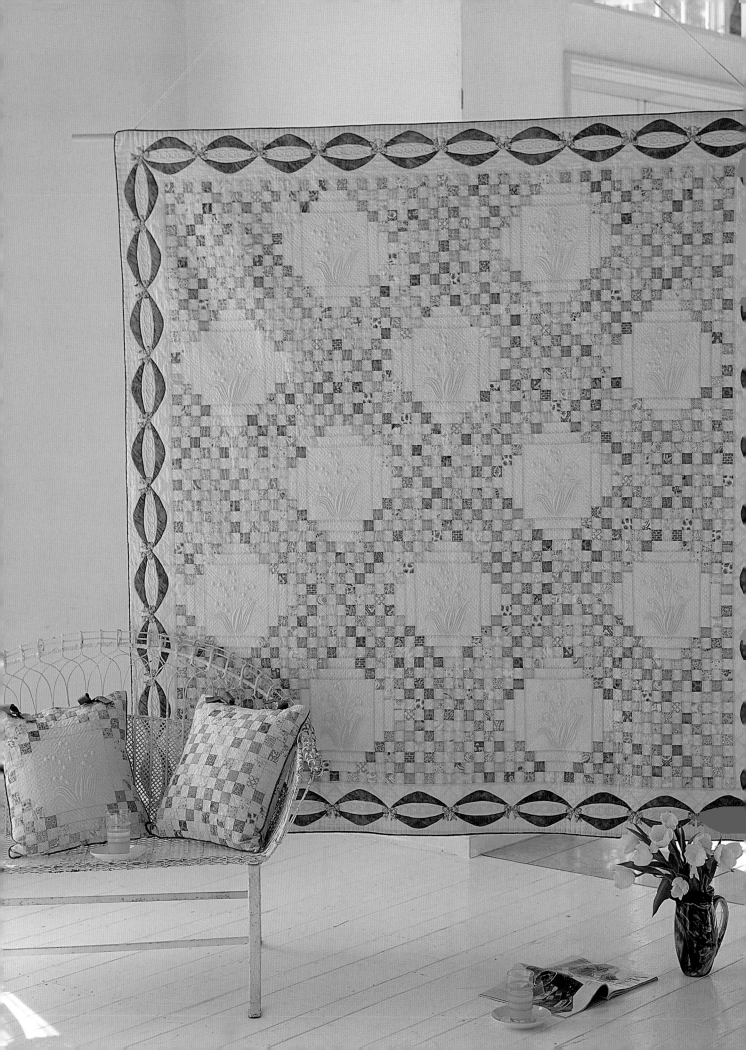

Spring Irish Chain Quilt

Finished Size: 75½" x 75½" (202.2 cm x 202.2 cm)
Techniques: Piecing/appliqué/trapunto (optional)

Made by Hiroko Shimbo
Photo by Norio Ando

This remarkable masterpiece quilt combines piecing, appliqué, and trapunto.
Spring Irish Chain celebrates early spring when sweetly fragrant blossoms
signal the end of winter. The trapunto lily of the valley can be adapted to
white-on-white embroidery in the alternate plain squares for a subtle touch.
Or, stitch the plain block in green embroidery floss on white fabric to
reproduce the vintage look of redwork.

FABRIC REQUIREMENTS

U.S.		Metric
5¼ yards	Background (Cut unpieced lengthwise strips for borders first.)	4.8 meters
2³⁄₈ yards	Assorted greens for blocks	2.2 meters
⅞ yard	Batiste for trapunto	80 cm
1¼ yards	Green for border scallops	1.1 meters
½ yard total	Assorted plaids for border bows	35 total
33 yards	Thick, lightweight yarn for trapunto	30 meters
½ yard	Green for binding	46 cm
4²⁄₃ yards	Backing	4.7 meters
80" x 80" squares	Batting	213 cm x 213 cm square

CUTTING

U.S.	Background	Metric
1⅝" x 1⅝" squares	Cut 1,084.	4.2 cm x 4.2 cm squares
1⅝" x 3⅞"	Cut 48.	4.2 cm x 10.2 cm
1⅝" x 6⅛"	Cut 48.	4.2 x 16.2 cm
10" x 10" squares	Cut 12.	25 cm x 25 cm squares
7" x 66"	Outer Side borders: Cut 2.	18 cm x 175 cm
7" x 77"	Outer Top and bottom borders: Cut 2.	18 cm x 206 cm

U.S.	Greens	Metric
1⅝" x 1⅝" squares	Cut 1,193.	4.2 cm x 4.2 cm squares
	Border scallops: Cut 80.	

U.S.	Batiste	Metric
10" x 10" squares	Cut 12.	25 cm x 25 cm squares

U.S.	Plaids	Metric
○	Bow knots: Cut 40.	○
	Bow tails: Cut 40 and 40r	
	Bow loops: Cut 40 and 40r.	

CHECKERBOARD BLOCK ASSEMBLY

1. Alternately sew six $1^5/_8$" x $1^5/_8$" green print (4.2 cm x 4.2 cm) squares with five $1^5/_8$" x $1^5/_8$" background (4.2 cm x 4.2 cm) squares, to make 78 strips of 11 squares each. Press seams toward the green print squares.

Press toward green squares.
Make 78

2. Alternately sew six $1^5/_8$" x $1^5/_8$" background (4.2 cm x 4.2 cm) squares with five $1^5/_8$" x $1^5/_8$" green print (4.2 cm x 4.2 cm) squares to make 65 strips of 11 squares each. Press seams toward the green print squares.

Press toward green squares.
Make 65

3. Alternately sew six of the strips made in Step 1 with five of the strips made in Step 2 to make one checkerboard block. Press carefully. Make 13 blocks.

Checkerboard block: Make 13.

TRAPUNTO

1. Trace the trapunto design onto the batiste squares.

2. Baste the traced squares to the wrong side of the background squares.

3. With very small hand stitches and polyester thread in a color to match the background fabric, outline the traced design through both the batiste and the background squares.

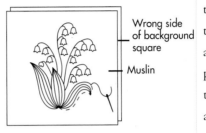

Wrong side of background square

Muslin

4. Thread a tapestry needle with the trapunto yarn. Do not knot the end. Working from the batiste side, insert the needle at one end of a motif. (Cut a small slit in the batiste only, if necessary, so you can insert the needle.) Channel the threaded needle between the lines of stitching (and between the batiste and background fabrics) to fill the design. When you come to the end of a traced area, cut the thread blunt with the fabric. Do not knot the end of the yarn. Slipstitch any slits in the batiste once the trapunto is complete.

Cut

Cut

For areas that are wider than the width of the yarn, fill the design with parallel lengths of the yarn.

5. When you have finished filling in the areas of the design, gently pull the fabric in opposite directions to allow the ends of the yarn to be pulled in between the fabrics. With the blunt end of your needle, push in any pieces of yarn remaining on the surface of the fabric and gently try to close up any holes in the fabric by moving the threads of the fabrics.

6. Carefully block your work to correct any distortion that might have occurred while stitching.

7. Cut the block to measure $8^3/_8$" x $8^3/_8$" (22.2 cm x 22.2 cm). Make 12 blocks.

TRAPUNTO BLOCK ASSEMBLY

1. Alternately sew $1^5/_8$" x $1^5/_8$" (4.2 cm x 4.2 cm) background squares to $1^5/_8$" x $1^5/_8$" (4.2 cm x 4.2 cm) green print squares to make 192 pairs as shown. Press seams toward green print squares.

Press

Make 192

2. With background squares on the outside edges, sew two pairs to each side of a 1⅝" x 3⅞" (4.2 cm x 10.2 cm) background rectangle to make Unit 1. Press seams toward green print squares. Make 24.

Press toward green squares.
Unit 1: Make 24.

3. Sew one 1⅝" x 1⅝" (4.2 cm x 4.2 cm) green print square and a pair to each side of a 1⅝" x 6⅛" (4.2 cm x 16.2 cm) background rectangle to make Unit 2. Press the seams toward the green print squares. Make 24.

Press toward green squares.
Unit 2: Make 24.

4. Sew one pair to each end of a 1 ⅝" x 3⅞" (4.2 cm x 10.2 cm) background rectangle. Press seams toward green print squares. Make 24.

Press
Unit 3: Make 24

5. Sew one 1⅝" x 1⅝" (4.2 cm x 4.2 cm) green print square to each end of a 1⅝" x 6⅛" (4.2 cm x 16.2 cm) background rectangle to make Unit 4. Press seams toward green print squares. Make 24.

Press
Unit 4: Make 24

6. Sew Unit 3 to Unit 4. Press seam toward Unit 4. Make 24.

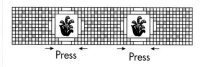

Unit 4

Unit 3 Press
Unit 3/4: Make 24.

7. With Unit 3 on the outside edge, sew one Unit 3/4 to each side of a trapunto square to make a center unit. Press seams toward the trapunto square. Make 12.

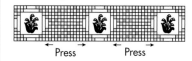

Press
Center Unit: Make 12.

8. To assemble the trapunto block: sew each Unit 1 to a Unit 2. Press seam toward Unit 2. With Unit 1 on the outside, sew Unit 1/2 combination to the top and bottom of the center unit as shown. Press seams open. Make 12 blocks.

Unit 1
Unit 2
Center unit
Unit 2
Unit 1

QUILT ASSEMBLY

1. Alternate three checkerboard blocks with two trapunto blocks to sew rows 1, 3, and 5. Press the seams toward the trapunto blocks.

Press Press

2. Alternate three trapunto blocks with two checkerboard blocks to sew rows 2 and 4. Press the seams toward the trapunto blocks.

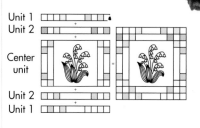

Press Press

3. Sew the five rows together. Press seams in one direction.

CHECKERBOARD BORDER

1. From the remaining green print fabric, cut 112 squares, each $1^5/_8$" x $1^5/_8$" (4.2 cm x 4.2cm).

2. Cut 112 background squares, each $1^5/_8$" x $1^5/_8$" (4.2 cm x 4.2 cm).

3. Starting and ending with a background square, alternately sew 27 green print squares with 28 background fabric squares for a strip of 55 squares. Press seams toward green print squares. Make two strips.

4. Sew the strips made in Step 3 to the top and bottom of the quilt top. Press toward the quilt top.

Assembly diagram

5. Starting and ending with a green print square, alternately sew 29 green print squares with 28 background fabric squares for a strip of 57 squares. Press seams toward the green print squares. Make two.

6. Sew the strips made in Step 5 to the sides of the quilt top. Press toward the quilt top.

APPLIQUÉ BORDER

1. The outer borders are cut slightly oversized to allow for shrinkage during appliqué. Lightly mark the finished sizes: 6" x $64^1/_8$" (15 cm x 171 cm) for the side borders; 6" x $75^1/_8$" (15 cm x 201 cm) for the top and bottom borders.

2. Use the appliqué method of your choice to center and appliqué 16 scallops (eight pairs) on each side border and 20 scallops (ten pairs) on the top and bottom borders.

3. Appliqué bows over the points where the scallops meet. First appliqué tails, then loops, and finally knots.

4. Measure the quilt top lengthwise through the center, and trim the side borders to this length x $6^1/_2$" (16.2 cm) wide. Sew side borders to the quilt top. Press seams toward the borders.

5. Measure the width of the quilt top through the center including the side borders, and trim the top and bottom borders to this length x $6^1/_2$" (16.2 cm) wide. Sew the top and bottom borders to the quilt top. Press the seams toward the borders.

6. Appliqué one pair of scallops on each corner of the border, extending from the last scallop sewn to the side border to the last scallop sewn on the top and bottom borders.

7. Appliqué bows over the points where the scallops meet at the corners and between the last two scallops on the side borders.

FINISHING

Layer and baste the backing, batting, and quilt top.

Quilting includes squares within squares in the background of the trapunto blocks. A pair of diagonal lines runs through all of the white squares; this design was extended to the inner scallop of the appliqué border. A chain was quilted inside the scallops, and parallel lines $5/_8$" (1.6 cm) apart were quilted perpendicular to the binding from the outer scallops.

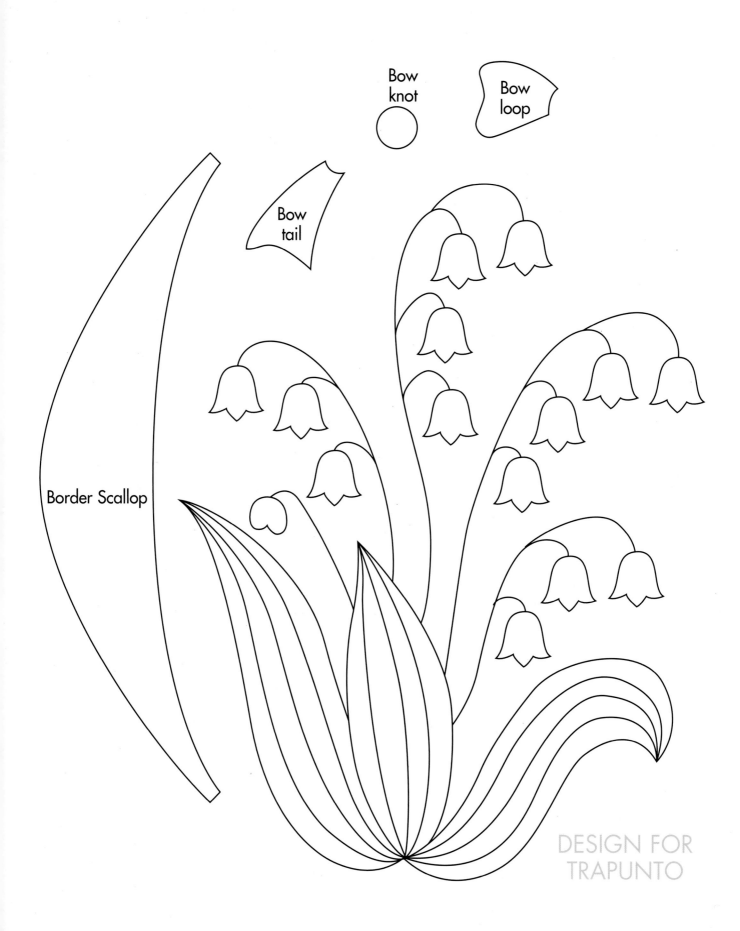

Bow knot

Bow loop

Bow tail

Border Scallop

DESIGN FOR TRAPUNTO

CHECKERBOARD PILLOW

Finished Size: $16\frac{7}{8}$" x $16\frac{7}{8}$" (45 cm x 45 cm)

Make coordinating decorative pillows to complement your masterpiece quilt. This version is a pretty checkerboard pillow decorated with piping and jaunty green bows.

U.S.	Fabric Requirements	Metric
$\frac{1}{3}$ yard	Background	30 cm
$\frac{1}{3}$ yard	Assorted greens for blocks	25 cm
$\frac{1}{2}$ yard	Green for ties and piping	40 cm
$\frac{2}{3}$ yard	Muslin for lining and facing	65 cm
$\frac{1}{2}$ yard	Backing	50 cm
$\frac{1}{4}$" x $1\frac{3}{4}$ yards	Cording for piping	0.6 cm x 153 cm
21" x 21" square	Batting	50 cm x 50 cm square
18" x 18"	Pillow form	45 cm x 45 cm

CUTTING

U.S.	Background	Metric
$1\frac{5}{8}$" x $1\frac{5}{8}$" squares	Cut 92.	4.2 cm x 4.2 cm squares
$1\frac{5}{8}$" x $3\frac{7}{8}$"	Cut 4.	4.2 cm x 10.2 cm
$1\frac{5}{8}$" x $6\frac{1}{8}$"	Cut 4.	4.2 cm x 16.2 cm

U.S.	Greens	Metric
1⁵⁄₈" x 1⁵⁄₈" squares	Cut 101.	4.2 cm x 4.2 cm squares
2³⁄₄" x 12¹⁄₄"	Ties: Cut 4.	7.2 cm x 31.2 cm
10" x 10" square	Piping: 60" (153 cm) of 1" (2.6 cm) wide bias strips	25 cm x 25 cm square

U.S.	Muslin	Metric
21" x 21" square	Lining	57 cm x 57 cm square
1¹⁄₂" x 34¹⁄₄"	Facing	3.7 cm x 91.2 cm

U.S.		Metric
17³⁄₈" x 17³⁄₈" square	Backing	46.2 cm x 46.2 cm square

PILLOW TOP ASSEMBLY

1. Alternately sew three 1⁵⁄₈" x 1 ⁵⁄₈" (4.2 cm x 4.2 cm) green print squares with two 1⁵⁄₈" x 1⁵⁄₈" (4.2 cm x 4.2 cm) background squares, to make a strip of five squares. Press the seams toward the green print squares. Make 19 strips.

Press toward green squares.
Make 19.

2. Alternately sew three 1⁵⁄₈" x 1 ⁵⁄₈" (4.2 cm x 4.2 cm) background squares with two 1⁵⁄₈" x 1⁵⁄₈" (4.2 cm x 4.2 cm) green print squares to make a strip of five squares. Press seams toward the green print squares. Make 18 strips.

Press toward green squares.
Make 18.

3. Alternately sew three of the strips made in Step 1 with two of the strips made in Step 2 to make one checkerboard block. Press carefully. Make five A blocks.

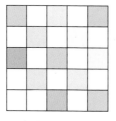

Block A: Make 5.

4. Sew one green print square to each side of a 3⁷⁄₈" (10.2 cm) long background strip. Press seams toward the green print squares. Make four units.

5. Sew one strip from Step 1, two strips from Step 2, one strip from Step 4, and one 6¹⁄₈" (16.2 cm) long background strip together as shown. Press. Make four B blocks.

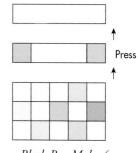

Block B: Make 4.

6. Sew the blocks together into rows as shown. Press.

7. Sew the rows together as shown. Press.

QUILTING

Layer and baste the batting between the pillow top and the lining.

Quilt pairs of diagonal lines through all of the background squares. The lines are $1/8$" (3 mm) apart.

FINISHING

1. Trim the batting and lining even with the edges of the pillow top.

2. Using diagonal seams, join the bias strips to make one continuous length for the piping.

3. Fold and pin the bias strip in half wrong sides together encasing the cording. Using a zipper foot, sew close to the cording. Be careful not to stretch the bias while sewing.

4. Pin and baste the piping to the right side of the fabric, so that the sewing line of the piping is just inside the seamline. Machine baste with a zipper foot close to the cording without crowding it.

5. With raw edges even, sew piping to the right side of three sides of the pillow top using a zipper foot.

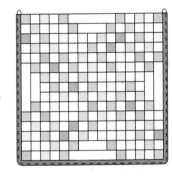

6. With right sides together, sew the pillow top to the backing along the three sides that are piped. Trim the corners. Turn the pillow right side out, and press carefully.

7. Fold the ties in half, lengthwise, right sides together. Sew along one short side and the long side of the tie as shown. Trim the corners. Turn the ties right side out, and press.

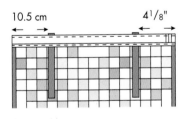

Trim

8. Sew the facing ends, right sides together. Press the seam open.

9. Finish one long side of the facing by folding and pressing $1/4$" (6 mm) to the wrong side twice, then hem along the narrow edge.

10. Baste the ties in place on the right side of the pillow top and backing, with each tie $4^1/8$" (10.5 cm) from the corner. With right sides together and raw edges even, sew the raw edge of the facing to the pillow cover opening, catching the ties in the seam.

10.5 cm $4^1/8$"

11. Turn the facing to the inside of the pillow top. Press. Hand sew the facing in place.

Wrong side

LILY OF THE VALLEY TRAPUNTO BLOCK PILLOW

Finished Size: 16⅞" x 16⅞" (45 cm x 45 cm)

Here's an easy way to practice the trapunto lily of the valley and create a sweet decorative accent; a perfect gift for a friend, or a treat for yourself.

U.S.	Fabric Requirements	Metric
¼ yard total	Assorted greens for blocks	25 cm total
½ yard	Background	45 cm
⅓ yard	Batiste for trapunto	30 cm
⅔ yard	Muslin for lining and facing	65 cm
½ yard	Backing	50 cm
½ yard	Green for ties and piping	40 cm
19½" x 19½" square	Batting	47 cm x 47 cm square
¼" x 1¾ yards	Cording for piping	0.6 cm x 153 cm
18" x 18"	Pillow form	45 cm x 45 cm

CUTTING

U.S.	Background	Metric
1⅝" x 1⅝" squares	Cut 68.	4.2 cm x 4.2 cm squares
1⅝" x 3⅞"	Cut 4.	4.2 cm x 10.2 cm
1⅝" x 6⅛"	Cut 4.	4.2 cm x 16.2 cm
10" x 10" square	Cut 1.	25 cm x 25 cm square

U.S.	Greens	Metric
1⅝" x 1⅝" squares	Cut 76.	4.2 cm x 4.2 cm squares
2¾" x 12¼"	Ties: Cut 4.	7.2 cm x 31.2 cm
10" x 10" square	Piping: 60" (153 cm) of 1" (2.6 cm) wide bias strips	25 cm x 25 cm square

U.S.		Metric
10" x 10" square	Batiste for trapunto	25 cm x 25 cm square
21" x 21" square	Lining	57 cm x 57 cm square
1½" x 34¼"	Facing	3.7 cm x 91.2 cm
17⅜" x 17⅜"	Backing	46.2 cm x 46.2 cm

TRAPUNTO CENTER

1. Refer to Trapunto, Steps 1–6 of quilt project, page 55.

2. Trim the trapunto center to measure 8⅜" x 8⅜" (22.2 cm x 22.2 cm).

CHECKERBOARD BORDERS

1. Sew background squares alternately with green print squares into rows as shown. Press seams toward green squares. Make two each.

Make 2 each.

2. Sew one 1⅝" x 3⅞" (4.2 cm x 10.2 cm) background strip between two sets of three background squares sewn alternately with three green print squares as shown. Press seams toward green squares. Make two.

3. Sew one 1⅝"" x 6⅛" (4.2 cm x 10.2 cm) background strip between two sets of three green print squares sewn alternately with two back-ground squares as shown. Press seams toward green squares. Make two.

4. Sew the strips (rows) made in Steps 1–3 together. Press. Make two. These are the top and bottom borders.

5. Sew background squares alternately between green print squares as shown. Press seams toward green squares. Make two each.

6. Sew one 1⅝" x 3⅞" (4.2 cm x 10.2 cm) background strip between pairs of background and green print squares. Press seams toward green squares. Make two.

7. Sew one 1⅝" x 6⅛" (4.2 cm x 16.2 cm) background strip between two green print squares. Press. Make two.

8. Sew strips (rows) made in steps 5–7 together. Press. Make two. These are the side borders.

Side Borders Make 2.

PILLOW TOP ASSEMBLY

1. Sew the side borders to each side of the trapunto center. Press.

2. Sew the top and bottom checkerboard borders to the pillow top. Press.

QUILTING

Layer and baste the batting between the pillow top and the lining.

Quilt pairs of diagonal lines ⅛" (3 mm) apart through all of the background squares.

FINISHING

Follow Steps 1–11 of Checkerboard Pillow on page 61 to complete the pillow.

INDEX

ABOUT THE EDITORS

Cyndy Lyle Rymer is an editor at C&T Publishing and a long-time quilter. She was the creator and editor of *Quilts for Guys,* a recent release from C&T. Cyndy lives in Danville, California.

Jennifer Rounds is a professional quiltmaker and freelance writer. She writes the "Feature Teacher" column for *The Quilter* magazine. Jennifer lives in Walnut Creek, California.

For a free book catalog:
C&T Publishing, Inc.
P.O. Box 1456
Lafayette, CA 94549
(800) 284-1114
Email: ctinfo@ctpub.com
Website: www.ctpub.com

For quilting supplies:
Cotton Patch Mail Order
3405 Hall Lane, Dept. CTB
Lafayette, CA 94549
(800) 835-4418
(925) 283-7883
Email: quiltusa@yahoo.com
Website: www.quiltusa.com

NOTE: Fabrics used in quilts shown may not be currently available since fabric manufacturers keep most fabrics in print for only a short time.